W9-CAE-959

The Fantasy Figure Artist's Reference File

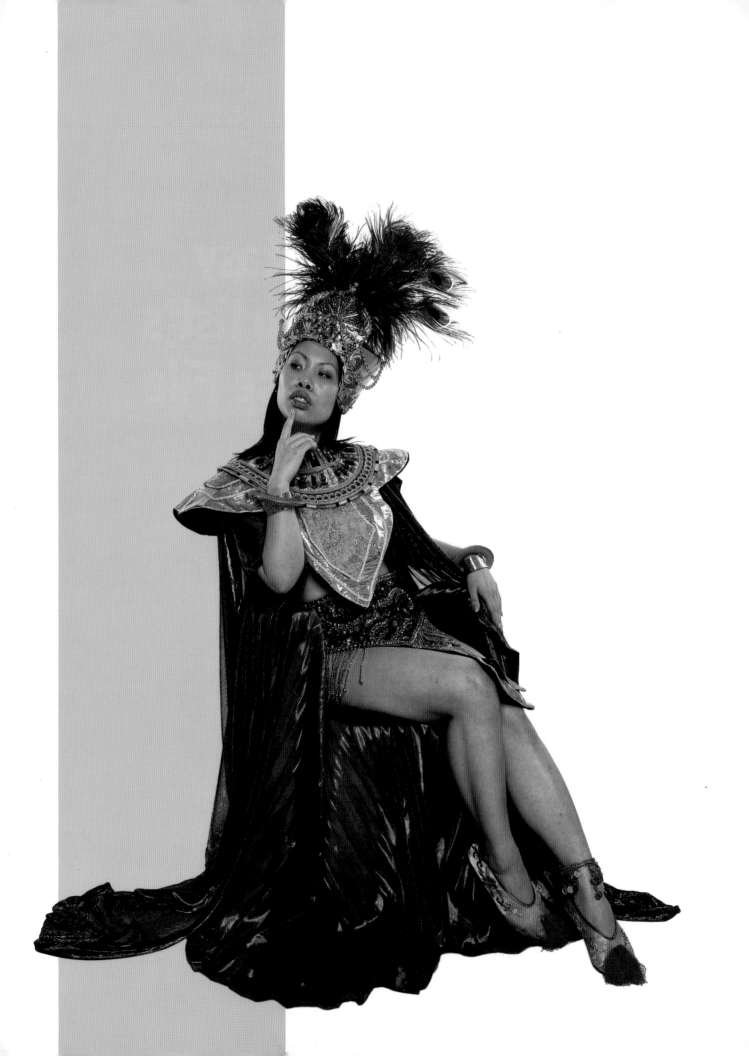

The Fantasy Figure Artist's Reference File

Hundreds of real-life photographs depicting extreme anatomy and dynamic action poses

Peter Evans

Foreword by Glenn Fabry

A QUARTO BOOK

First edition for North America published in
2006 by Barron's Educational Series, Inc.

Copyright © 2006 Quarto Inc.

All rights reserved.
No part of this book may be reproduced in any
form, by photostat, microfilm, xerography, or
any other means, or incorporated into any
information retrieval system, electronic or
mechanical, without the written permission of
the copyright owner.

All inquiries should be addressed to:
Barron's Educational Series, Inc.
250 Wireless Boulevard
Hauppauge, New York 11788
www.barronseduc.com

ISBN-13: 978-0-7641-7961-7
ISBN-10: 0-7641-7961-6

Library of Congress Catalog Card No.
2005929080

Conceived, designed, and produced by
Quarto Publishing plc
The Old Brewery
6 Blundell Street
London
N7 9BH

QUAR.FFA

Project editor: Liz Pasfield
Art editors: Anna Knight, Julie Joubinaux
Assistant art director: Penny Cobb
Copy editor: Claire Waite Brown
Designer: Tanya Devonshire-Jones
Photographers: Martin Norris, Philip Wilkins
Illustrators: Anne Stokes, Patrick McEvoy

Art director: Moira Clinch
Publisher: Paul Carslake

Manufactured by Provision Pte Ltd, Singapore
Printed by SNP Leefung Holding Limited, China

9 8 7 6 5 4 3 2 1

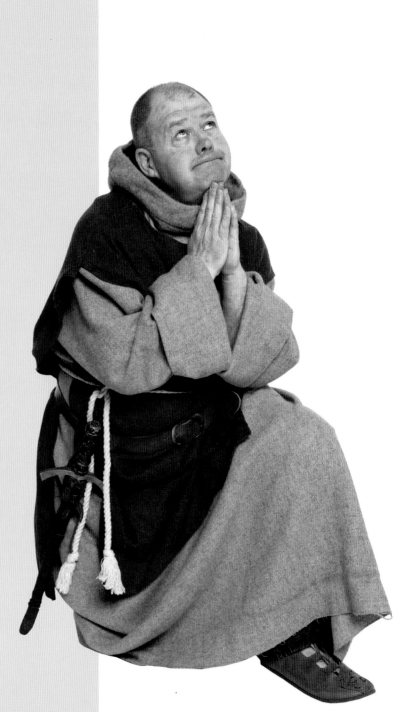

Contents

Foreword by Glenn Fabry 6
How to Use This Book 8
Body Types 10

Fantasy Swipe File 18
Barbarian Warrior 22
Warrior Woman 28
Elven Warrior 34
Elven Queen 40
Fairy 46
Princess 54
Wicked Sorceress 60
Warrior Prince 66
Wizard 72
Evil Sorcerer 78
Warrior Dwarf 84
Cleric 90
Peasant Boy 98
Peasant Girl 104
Norseman 112
Goblin 118

Close-ups 124
Expressions 124
Hands 128
Accessories 132
Lighting 136

Now Go Paint 140
Comradeship 140
Fighting and Combat 144
Artist at Work 150

Resources 156
Index 158
Credits 160

Foreword

I love this book because it's just so useful.

Being a fantasy artist is a bit like being a one-person movie studio, where you are expected to bring out something that stands alongside the latest computer-generated Hollywood epic and satisfy the ever-more-educated eye of not just the general public, but those with a special interest in the very type of imagery you're attempting to bring to life. Nine times out of ten it's just you on your own, with no team of researchers or gang of helpful, well-built, extraordinary, attractive people willing to fling themselves into whatever bizarre contortions you consider would make an eye-catching image for reference for your book cover, trading card, record sleeve, or poster. With this in mind, illustrators need all the help they can get. And that is where this book comes in, as a visual aid to assist you in bridging the gap between your artistic conceptions and your completed piece. I can't count the number of times I've been to other artists' studios and

seen on the bookshelves the same reference books, such as Bridgman's *Constructive Anatomy,* very useful, and *The Human Figure in Motion,* by Eadweard Muybridge, who was the first person to collect a series of photographic studies as an aid to artists. These photographs, however, were taken a very long time ago and are frustratingly blurry and short of detail. Nowadays, of course, with high-definition lenses, the improvement in the clarity of image is immense, which helps to make this book all the more useful.

The Fantasy Figure Artist's Reference File is also the first collection with the added bonus of apposite costumery. As an illustrator, it's not just the figure, face, and muscles that you've got to get right, it's the costume details and the drapery. I've lost count of the times I've had to stand in front of a mirror with a towel wrapped around my head in order to get the folds of a cloak right. Here there are also classic fantasy poses and facial expressions, and a collection of archetypal spear carriers from the fantasy art pantheon. Brilliant.

Glenn Fabry

How to Use This Book

Body Types and Fantasy Swipe File

Before entering the swipe file, the three main body types are introduced. The swipe file is organized by fantasy archetype. Each archetype has six or eight pages featuring a range of classic poses for the artist to use as reference material. The photographs are annotated to draw the artist's attention to the finer points of anatomical study.

Body types
The three main body types are introduced before the fantasy archetypes are examined in detail.

Introducing the archetype
Sportswear sequences show the model in a series of action poses with helpful annotations identifying key anatomical features.

Getting dressed
A series of images shows the progression of the archetype's costume from undergarments to complete outfit.

▪ Two classic in-character poses are shown from different angles and viewpoints.

Classic poses
A selection of typical poses in costume is included for the artist to copy or adapt.

▪ The archetype is introduced and vital statistics are listed.

▪ Anatomical information is clearly shown from different viewpoints.

▪ Different facial expressions provide plenty of inspiration.

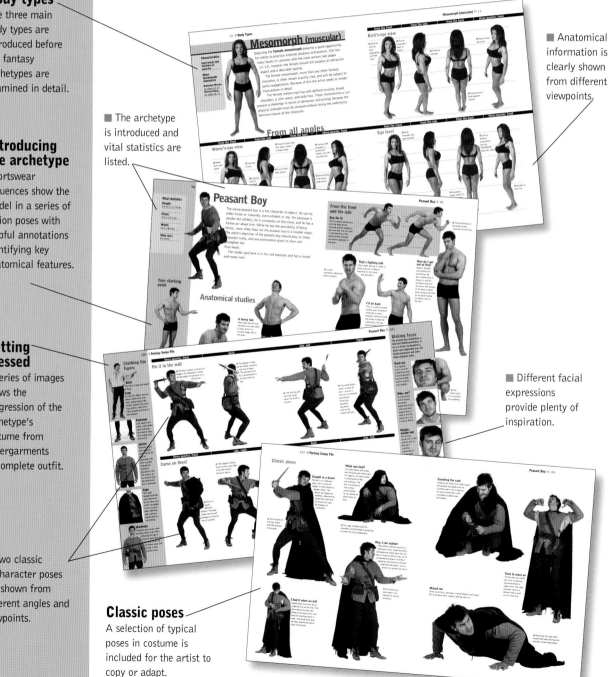

Close-ups

Useful close-up references for the artist, such as expressions, hands, and accessories, are included. Advice on adapting lighting to create effective atmospheres is also a feature of this section.

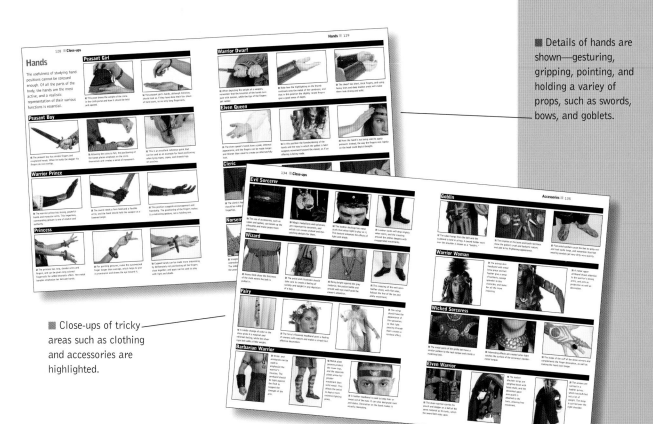

■ Details of hands are shown—gesturing, gripping, pointing, and holding a variey of props, such as swords, bows, and goblets.

■ Close-ups of tricky areas such as clothing and accessories are highlighted.

Now Go Paint

Using models from the book as inspiration, a series of sketches and a step-by-step demonstration of a finished work show in detail how you can achieve polished paintings.

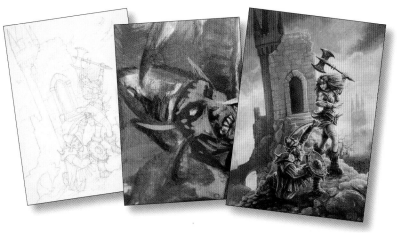

CD

All of the reference images are included on the accompanying CD. The CD is compatible with both Mac and PC systems, and the digital images can be used as references for drawing.
On opening the CD you will find numbered folders that correspond with the page numbers of the book. The images are contained within each folder.

This book contains rights-free images intended to provide reference material for the use of artists and illustrators in the creation of their work, and as such these images may be reproduced or adapted free of charge. However, where the intention is to display the images as reference material, no part of this collection of images may be reproduced in any form without the written permission of the copyright holder.

Mesomorph (muscular)

Characteristics

Good muscle tone
Feminine yet powerful

Other mesomorph characters

Barbarian Warrior
see pages 22–27
Warrior Prince
see pages 66–71

Depicting the **female mesomorph** presents a good opportunity for artists to practice extreme anatomy and posture. She has many facets in common with the male version (see pages 12–13); however the female should still possess an attractive aspect and a desirable quality.

The female mesomorph, more than any other fantasy character, is often shown scantily clad, and will be subject to some exaggeration. Because of this the artist needs to render musculature in detail.

The female mesomorph has well-defined muscles, broad shoulders, a slim waist, and wide hips. These characteristics can present a challenge in terms of demeanor and posing, because the physical strength must be stressed without losing the underlying feminine nature of the character.

From all angles

| from the front | from the side | from the back | three-quarter, front |

Worm's-eye view

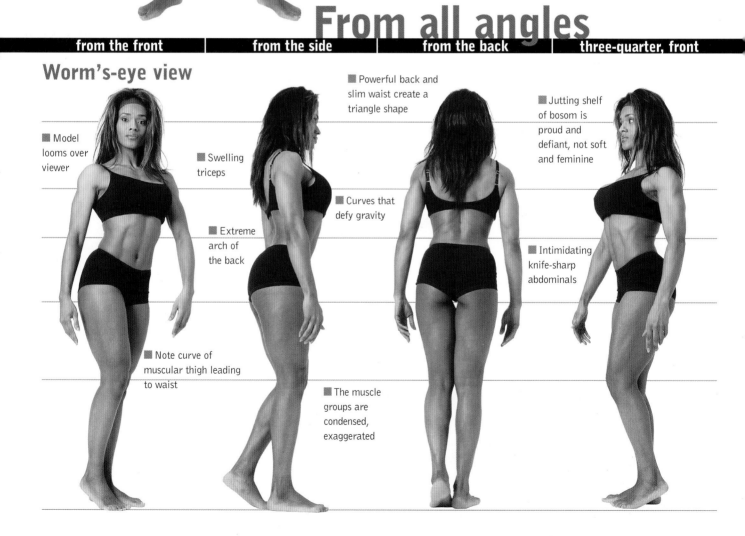

■ Model looms over viewer

■ Note curve of muscular thigh leading to waist

■ Swelling triceps

■ Extreme arch of the back

■ The muscle groups are condensed, exaggerated

■ Powerful back and slim waist create a triangle shape

■ Curves that defy gravity

■ Jutting shelf of bosom is proud and defiant, not soft and feminine

■ Intimidating knife-sharp abdominals

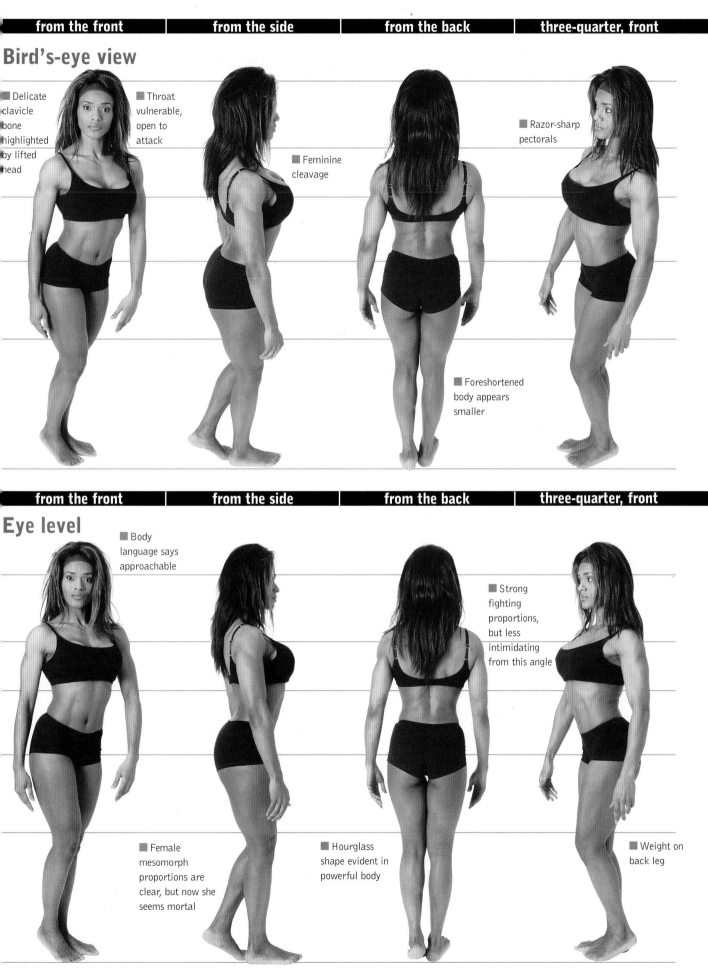

from the front	from the side	from the back	three-quarter, front

Bird's-eye view

▨ Delicate clavicle bone highlighted by lifted head

▨ Throat vulnerable, open to attack

▨ Feminine cleavage

▨ Razor-sharp pectorals

▨ Foreshortened body appears smaller

from the front	from the side	from the back	three-quarter, front

Eye level

▨ Body language says approachable

▨ Strong fighting proportions, but less intimidating from this angle

▨ Female mesomorph proportions are clear, but now she seems mortal

▨ Hourglass shape evident in powerful body

▨ Weight on back leg

Mesomorph (muscular)

Characteristics

Strong boned

Toned, powerful body

Pronounced muscle development

Other mesomorph characters

Warrior Woman
see pages 28–33

Warrior Prince
see pages 66–71

The **male mesomorph** has chiseled features, solid and well-developed muscle tone, wide shoulders, and a narrow waist, and the body aspect as a whole is robust and powerful. With this character there is the suggestion of healthy living, great physical strength and stamina, and a robust constitution. The build should be both attractive and intimidating.

Mesomorphs are often depicted wearing little more than a loincloth and boots, so the artist needs to have a good working knowledge of how muscles react to stress and strain. However, even fully clothed the suggestion of a strong body needs to be defined. In fantasy art, anatomy and musculature can be broadened and overstated to create a more powerful image. This character will be required to undertake extreme postures and moves, and a certain amount of embellishment can do no harm, and can enhance the representation of action.

From all angles

| from the front | from the side | from the back | three-quarter, front |

Worm's-eye view

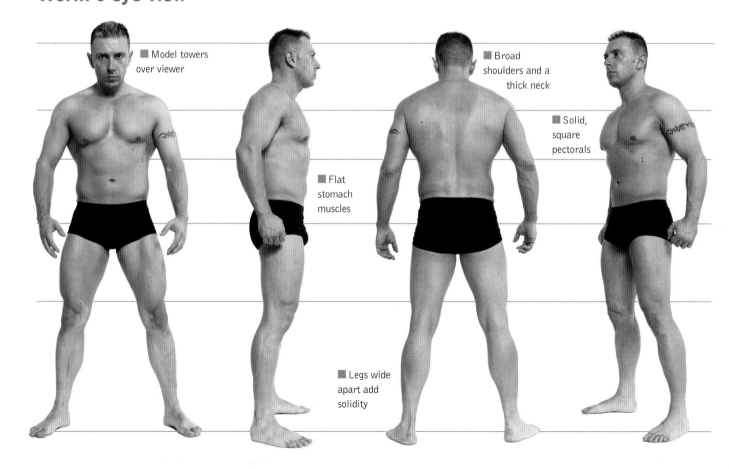

■ Model towers over viewer

■ Flat stomach muscles

■ Legs wide apart add solidity

■ Broad shoulders and a thick neck

■ Solid, square pectorals

from the front	from the side	from the back	three-quarter, front

Bird's-eye view

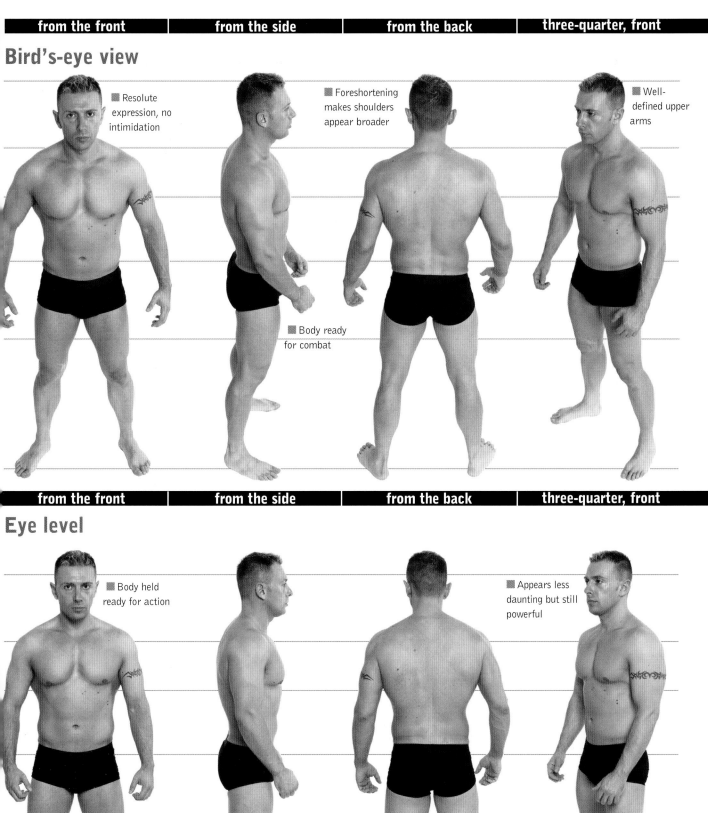

■ Resolute expression, no intimidation

■ Foreshortening makes shoulders appear broader

■ Well-defined upper arms

■ Body ready for combat

from the front	from the side	from the back	three-quarter, front

Eye level

■ Body held ready for action

■ Appears less daunting but still powerful

■ Strong thigh and calf muscles

■ Body weight evenly balanced

Endomorph (stocky)

Characteristics

Hefty build
Rounded limbs
Large stomach

Other endomorph characters

Norseman
see pages 112–117

The **endomorph** body type is big and heavy, with a soft rounded shape, large stomach, and muscles hidden under layers of fat. Female endomorphs have a similar shape to the male, however with males, as the body becomes large and fat, it can take on a feminine appearance. Lack of firm muscle tone can give male pectoral muscles the look of breasts.

Endomorphs should stand a little under average height, because being short adds to the feeling of stocky solidity, and the head, hands, and feet may look smaller and out of proportion due to the overall size of the body.

Although the overall appearance is fleshy, the endomorph need not be flabby, and while their muscles are not well defined, they can be quite solid and compact.

From all angles

| from the front | from the side | from the back | three-quarter, front |

Worm's-eye view

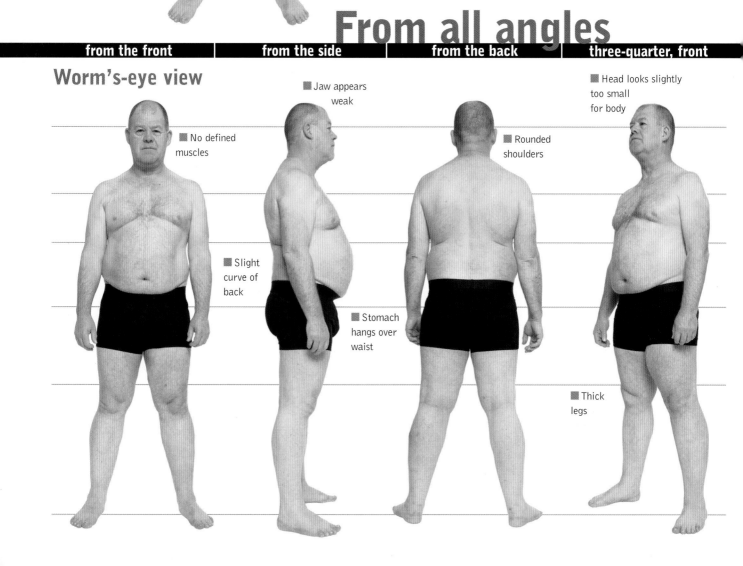

■ No defined muscles

■ Jaw appears weak

■ Slight curve of back

■ Rounded shoulders

■ Stomach hangs over waist

■ Head looks slightly too small for body

■ Thick legs

from the front	from the side	from the back	three-quarter, front

Bird's-eye view

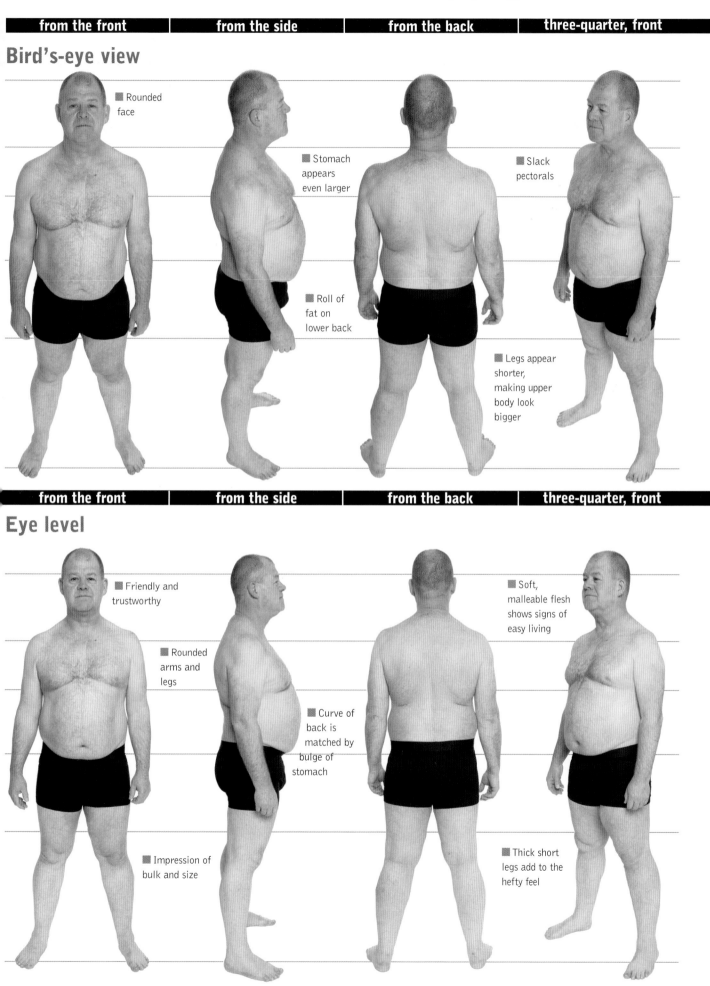

■ Rounded face

■ Stomach appears even larger

■ Slack pectorals

■ Roll of fat on lower back

■ Legs appear shorter, making upper body look bigger

from the front	from the side	from the back	three-quarter, front

Eye level

■ Friendly and trustworthy

■ Rounded arms and legs

■ Soft, malleable flesh shows signs of easy living

■ Curve of back is matched by bulge of stomach

■ Impression of bulk and size

■ Thick short legs add to the hefty feel

Ectomorph (slender)

Characteristics

Slight build
Well-defined muscles
Narrow waist

Other ectomorph characters

Elven Queen
see pages 40–45
Wicked Sorceress
see pages 60–65

The elven warrior represents the **ectomorph** body group and is of a slight build with delicate features. This type is also usually of middle to average height and youthful looking. Ectomorphs have a slender, well-proportioned physique with flat stomachs and slim waists and hips. The muscles are well defined as there is little spare flesh on the body.

Most depictions of fantasy females are of this body type. The general look is very attractive, and slenderness in a female is considered alluring. Wizards are also included in this group, but they tend to present an older and more shrunken aspect to reinforce the feeling of age.

Any successful rendering of ectomorphs requires a good working knowledge of the male and female skeleton and bone structure, as often the bones will be visible through the overlaying skin.

From all angles

| from the front | from the side | from the back | three-quarter, front |

Worm's-eye view

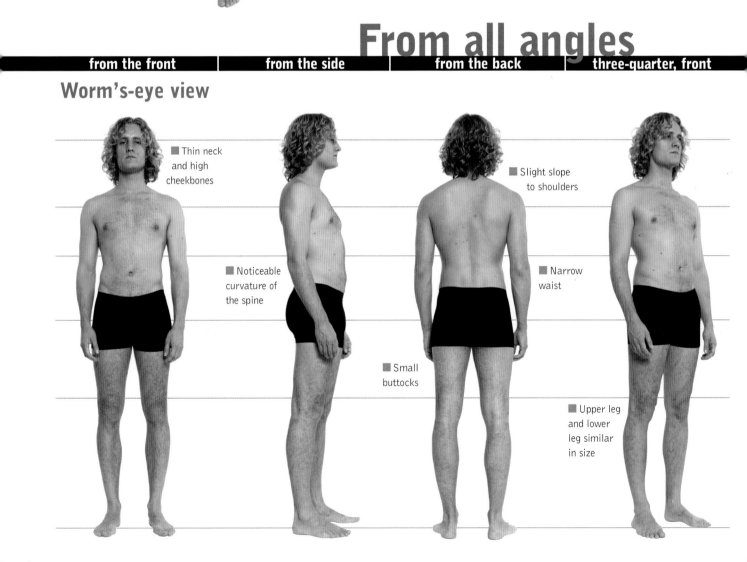

■ Thin neck and high cheekbones

■ Noticeable curvature of the spine

■ Small buttocks

■ Slight slope to shoulders

■ Narrow waist

■ Upper leg and lower leg similar in size

from the front	from the side	from the back	three-quarter, front

Bird's-eye view

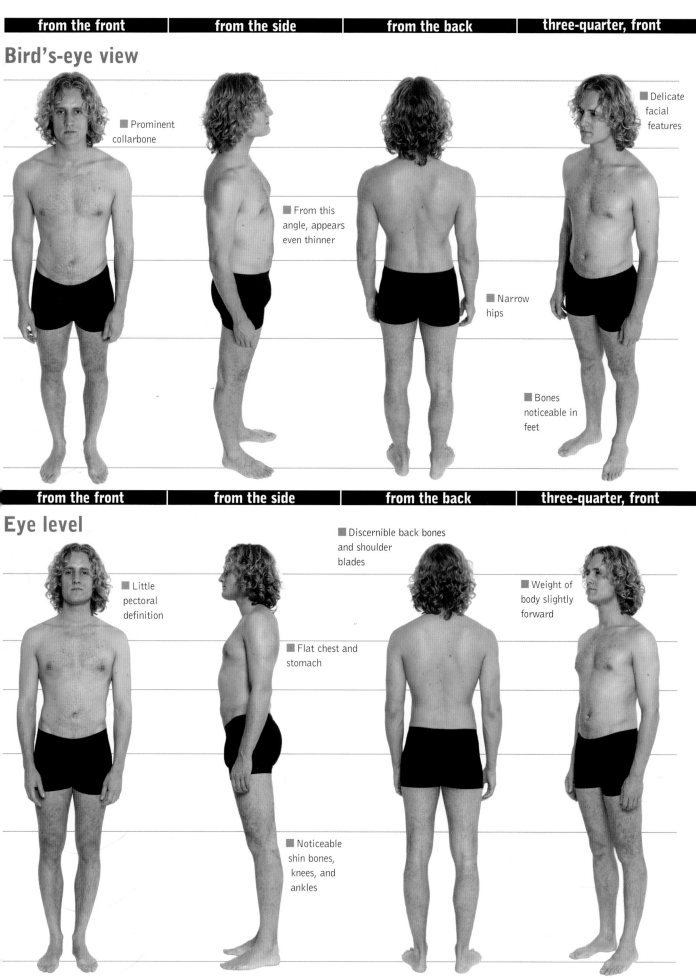

■ Prominent collarbone

■ From this angle, appears even thinner

■ Narrow hips

■ Delicate facial features

■ Bones noticeable in feet

from the front	from the side	from the back	three-quarter, front

Eye level

■ Little pectoral definition

■ Discernible back bones and shoulder blades

■ Flat chest and stomach

■ Weight of body slightly forward

■ Noticeable shin bones, knees, and ankles

Fantasy Swipe File

All of the fantasy archetypes in the book are shown over the following few pages. Just turn to the correct page to find fantastic references for creating great artwork.

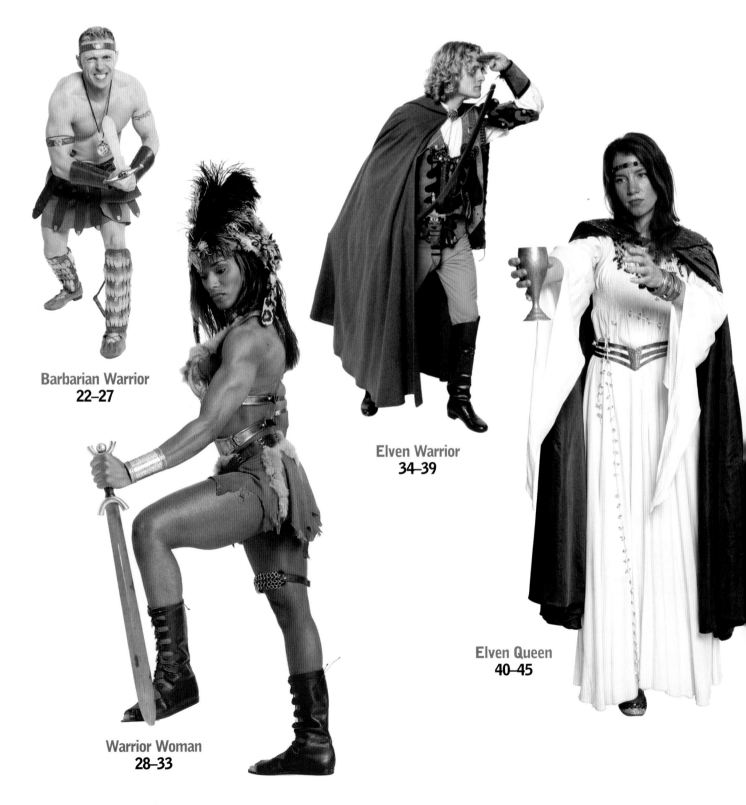

Barbarian Warrior
22–27

Warrior Woman
28–33

Elven Warrior
34–39

Elven Queen
40–45

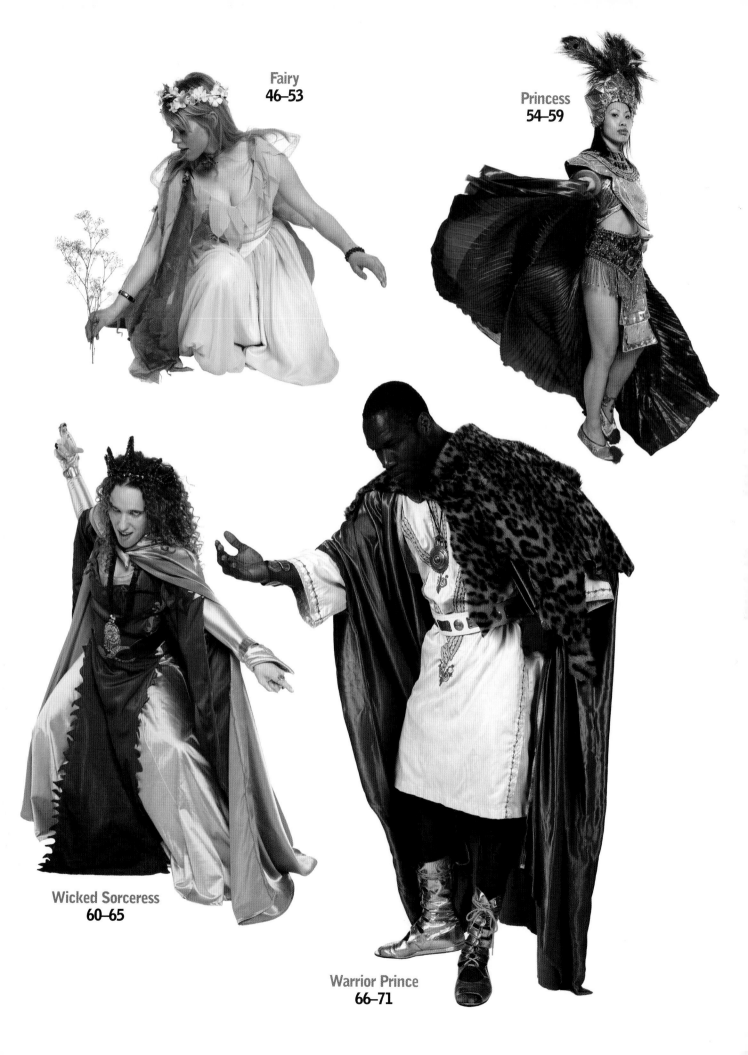

Fairy
46–53

Princess
54–59

Wicked Sorceress
60–65

Warrior Prince
66–71

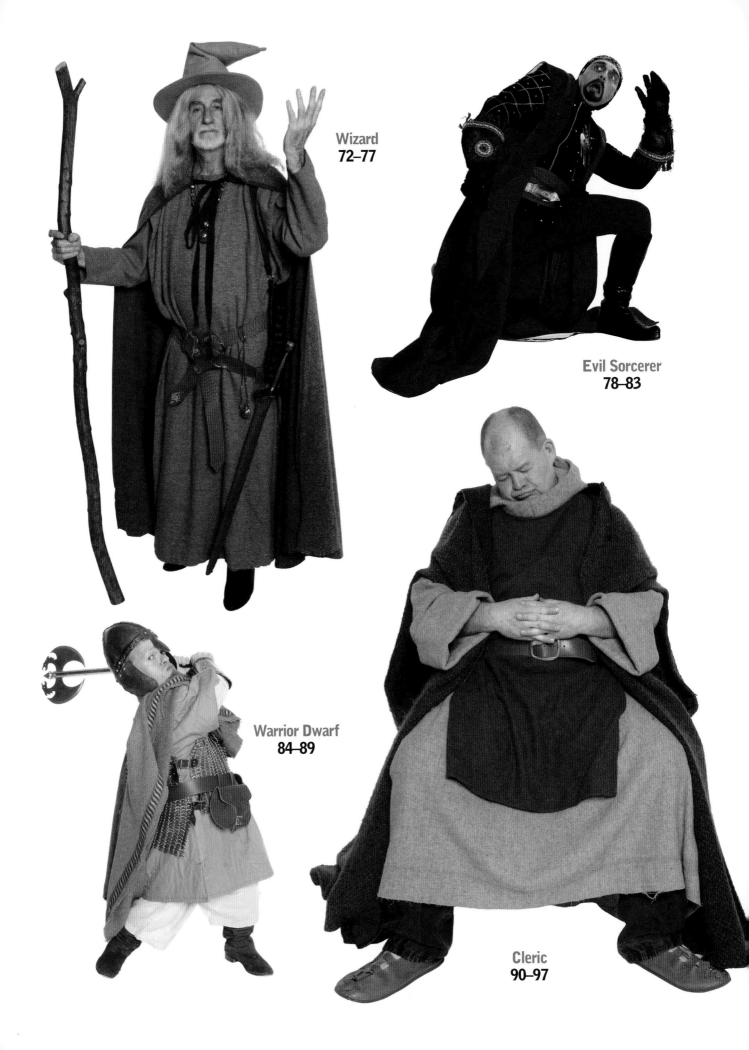

Wizard
72–77

Evil Sorcerer
78–83

Warrior Dwarf
84–89

Cleric
90–97

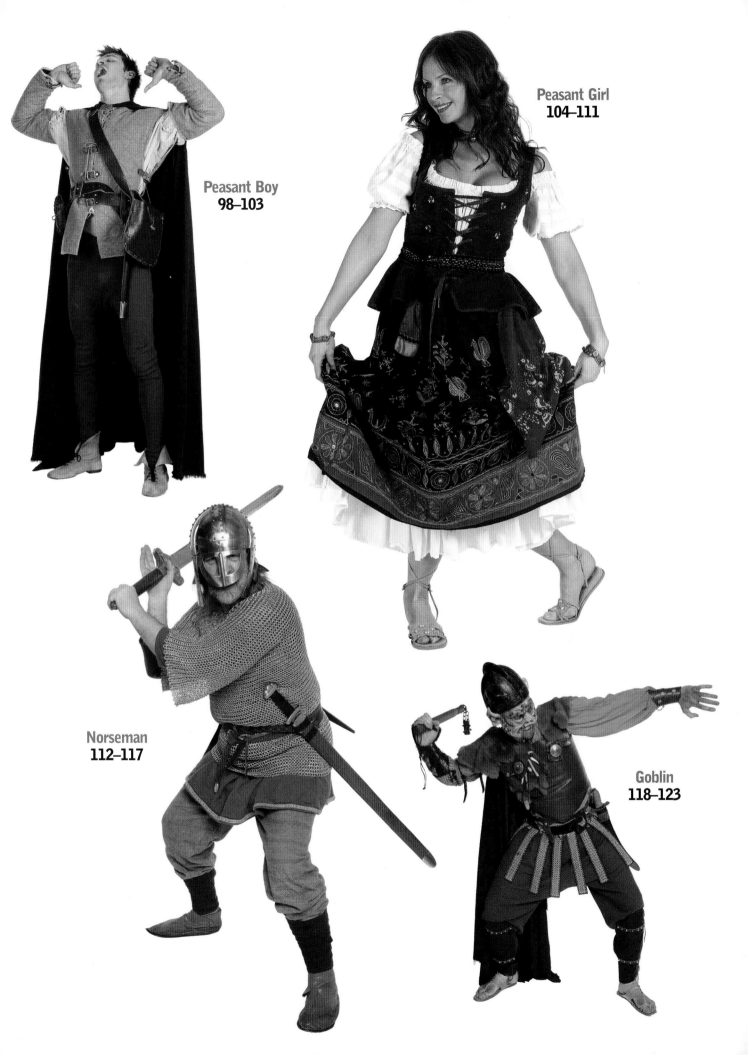

Peasant Boy
98–103

Peasant Girl
104–111

Norseman
112–117

Goblin
118–123

Barbarian Warrior

The barbarian warrior is one of the most popular inhabitants of the fantasy world. He is the archetypal hero who fights the forces of chaos and evil and laughs in the face of danger.

The barbarian should not be all muscles, sweat, and blood-stained blades. It can be just as satisfying to show him relaxing, and he needs to be given emotions as well as weapons.

The temptation to make him look like he has a steroid addiction should also be avoided. Overemphasizing the musculature can make him look grotesque and deformed.

Vital statistics

Height:
6 ft (1.83 m)

Chest:
44 in. (112 cm)

Waist:
34 in. (86 cm)

Shoe size:
9½ (9/44)

Your starting point

A well-defined physique

The barbarian has a very well-defined physique and muscle mass, but is not overdeveloped. Broad shoulders, slim waist, strong hips and upper thighs are what is required for an acceptable depiction.

Anatomical studies

All together or one at a time

This battle stance employs a tension in both the arms and legs to give it a feeling of contained power. The arms are out, with the hands gripping weapons (or a shield in the left hand).

■ The legs are wide apart and the feet are turned out for extra stability.

■ Pay attention to the muscles of the throwing arm.

A mighty throw

This position is used for throwing spears or lances. The back leg is bent to compensate for the weight of the weapon, while the other leg acts as a counterpivot. The force of the throw will come from the upper body, with the right hand turning to throw, sighting the lance at the tip of the opposite hand.

From the back and the side

Back view
This is a classic "coiled spring" pose. It suggests that the barbarian could leap into action suddenly if necessary.

Three-quarter view
The well-defined pectoral and arm muscles show that the character is used to physical exertion.

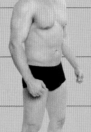

Side view
When depicting this impressive build, there must be a realization that these muscles are the result of outdoor living and physical combat, not hours spent in the gym.

Hack attack
A two-handed attack posture can be used with either an ax or a broadsword. The sweep of the shoulder and stomach muscles turning maintain the blade, so that the elbow of the lower arm ends up level with the forward knee. The leg can then be straightened and the arms swung back for a further blow.

Into battle
The barbarian is running at full speed. The firm leg muscles and position of the arms stress the rapidity of movement.

Victory
Moving forward, the arched back and pushed-out chest make this pose dynamic, while the tensed, raised arm and upward tilt of the head gives it a noble and imperious bearing.

Defending
The kneeling pose is one that can be adopted to protect the body from downward blows. The left arm is raised to eye level to protect the head, using a shield or arm guards.

▮ The sword arm is held low and away from the body to allow a counterstroke.

Watching and waiting
This standing pose is given a sense of power by the way the chest and arm muscles have been pumped up. The model's athletic physique shows his strength and sturdiness, even in a casual pose.

Clothing the figure

Wardrobe

The barbarian wears minimal clothing. This serves to emphasize his athletic build and the play of muscle and sinew. He relies on physical strength and agility, so body armor is rarely worn. Here he wears just a simple leather loincloth.

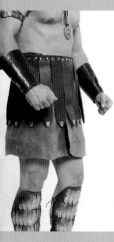

Footwear

Leather laced moccasin boots are also kept simple.

Protection

The thick strips of a leather tasset skirt give protection and allow for ease of movement. Greave shin guards consisting of metal plates on leather backing are kept in place with cross-lacing.

Wrist guards

The leather of the vambrace wrist guards is boiled to harden it for deflecting sword blows. There is metal decoration on the medallions and armbands.

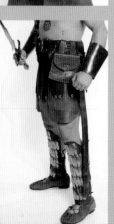

Scabbard, belt, and pouch

The barbarian also wears a soft leather sword scabbard, a belt with ornamental metal bosses, and a pouch for personal effects.

front	side

Ready to die?

■ Sword and dagger can be used both for attack and defense. His opponents don't know what he will use first and must try to defend themselves from slash, thrust, or stab.

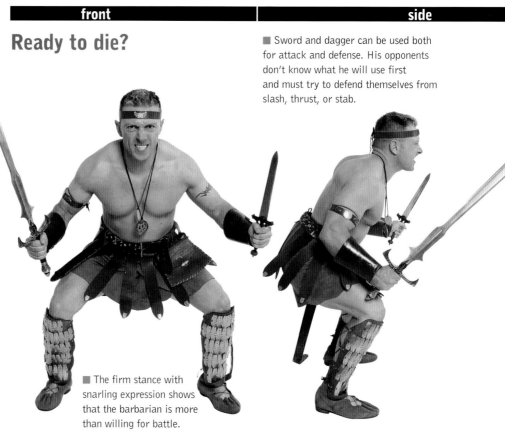

■ The firm stance with snarling expression shows that the barbarian is more than willing for battle.

front	three-quarter, front

The final blow

■ The sword is firmly gripped in both hands to add to the force of the downward slice.

■ The barbarian puts all his strength and fury into one single killing blow. The look on his face shows battle rage—this might be the only chance he'll get.

three-quarter, front

back

■ Neck and shoulder muscles are tensed, as are the leg muscles supporting the weight of the body.

■ The legs must take the strain because the arms need to be able to use the sword and dagger effectively. The feet are placed wide apart so that the body can be twisted in either direction without compromising stability.

back

side

■ The shoulders are pushed back, the shoulder blades almost touching. This position cannot be maintained for long. It's do or die.

■ The bend of the front leg holds the position. The other leg will act as a piston to push the upper body forward to increase momentum as the blade is brought down.

Making faces

Say that again!
The thin lips and hard stare warn others not to upset him.

That's one big troll!
The upward stare, wide eyes, and open mouth show that the barbarian can be surprised, but this is a look of shock rather than fear.

Battle cry
The face is contorted, with deep furrows around the mouth and eyes. The sinews on the neck are taut and the head is pushed forward. This lets us see the amount of effort put into the action.

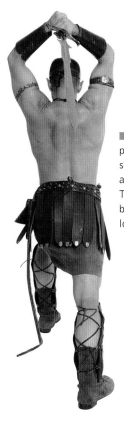

Classic poses

FIGHTING POSES

Here are some more examples of the barbarian's use of weapons and the way they are held. The artist should show that swords, axes, and such have weight and heft that affect the way the user stands and moves.

■ Outstaring makes his opponent nervous.

I'm ready, are you?

Crouching at the ready, the barbarian waits for his enemy to attack. His body is turned slightly to the side, and the sword is held in such a way that it can be used for either an upward thrust or an overhead cut.

Last man standing

Here, the whole body is tensed. The position of the arms, with both hands gripping the sword, and bend of the knee suggest that he is drawing on his last reserves of strength to save the day.

■ The sword blade is turned on its edge, making it even more imposing.

Meet your ancestors

Here the barbarian is about to skewer a swamp monster or similar chaos creature. His attention is fixed on where the sword will end up.

Follow me!

This pose has a certain dignity to it. The raised sword arm and forward thrust of the upper body create a sense of purpose and exaltation. This could depict a victory won on the field of battle or in the arena.

■ The straight legs will help the blade travel down in a clean line.

CASUAL POSES

The following poses show the barbarian in noncombat poses, however there is still more than a hint of belligerence in his attitude.

◼ His unsheathed sword lies across his knees, and his direct stare captures the attention.

Waiting for the command

Standing with one foot raised on a rock, or a dead creature, the hands resting on the sword tell us that, although at rest, he could fight again if need be.

◼ The leather band and tattoos on his upper arms emphasize the muscles.

Did you speak?

The way his hand strokes his chin shows that the barbarian is deep in thought.

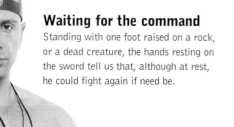

Keeping it keen

Carefully examining his well-worn blade, a warrior needs to keep the tools of his trade in good condition and always ready to use.

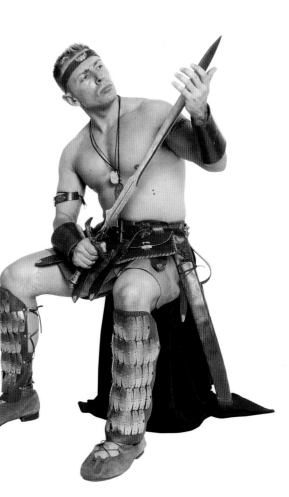

Vital statistics

Height:
5 ft 6 in. (1.67 m)

Dress size:
10 (12/38)

Shoe size:
8 (6/39.5)

Warrior Woman

The warrior woman is brave, honorable, and resolute, a worthy companion and a feared foe. She presents a good opportunity for artists to practice extreme anatomy and posture. More than any other fantasy character, she will be subject to exaggeration and, as she is usually scantily clad, the artist will need to render musculature in detail.

She also presents a challenge in terms of her general demeanor and posture. She is the most active of characters and will be portrayed in dynamic poses, which will include extreme perspective of the body and exaggerated facial expressions.

Your starting point

■ The back leg is used to absorb the force of the blow, while the upper body and arms create a counterpressure to block an opponent's strike.

Anatomical studies

Slice and dice

A useful pose to use as reference for back views and to study how the spine and shoulder blades move. Any weapon will have a certain weight that will affect the pull of the muscles. The greater the heft, the more the muscles will bulge, especially in the upper arms.

Best defense

This position is essentially used to deliver a counterblow or a parry before launching a counterattack. This position is particularly useful when using a battle-ax or double-handed broadsword.

Strength and agility

The model here has a very powerful, muscular build and looks to be both physically strong and active. Her broad shoulders and back make her waist look slimmer and hips wider.

■ The area at the base of the spine and top of the hips shows the stress and effort required. Paying attention to these considerations will ensure that you realize a greater realism in your artworks.

From the back and the side

The warrior's stance

This particular pose emphasizes the "coiled spring" concept, in that, although the warrior is simply standing, the amount of tension in her body suggests that she can move in any direction at speed with little warning.

The position of her arms, out by her sides, accentuates the tautness of her shoulders and adds to the feeling of suspended movement.

Say that again!

Overhearing a negative comment, the warrior woman turns and asks the unfortunate person to repeat the aside. Her clenched fists and the three-quarter turn of her upper body show that the reaction has been considered. A slow, thoughtful movement can be much more intimidating than a sudden, angry one.

■ The firm set of her lips and the hard look of her eyes reveal that she is angry.

From the back and the side

Shield wall

This pose, moving forward with tenacity and determination, evokes the field of battle as the warrior woman advances toward the enemy. The hand just below the chin could be holding a shield for protection, while the other holds a spear or sword, ready for close combat.

The slight curve of the back would be due to the pull of the weight of the shield and the grip and tension needed to keep it in place. The pressure exerted on the legs can be seen by the swell of the calf muscles. An appreciable amount of dynamism would have to be maintained as the warrior woman moves into the fray.

■ The expression on her face shows that she fears nobody and will not let anything stand in her way.

To the throne room

Adopting the firm, purposeful stride of the seasoned fighter, the warrior woman makes her way through the crowd. The way her arms are swinging out creates a wide body space around her, clearing a path. Her shoulders move in a direction counter to her hips, making the movement halfway between a march and a walk. The way characters move can give visual clues as to their personalities: barbarians stride, rogues saunter, and villains creep.

■ The crouching pose allows the body to relax slightly, but her raised arms and fixed stare create a sense of anxiety.

Watching and waiting

Here the warrior woman pauses before going into action. She could be slowly sneaking up on someone, her back to the wall of a dungeon as she edges around a door, or resting on the field of battle before the next attack comes.

Clothing the figure

The warrior's wardrobe

Costume enhances her cleavage and showcases the obligatory exposed midriff.

Footwear

Shoes are practical for speed, but also indicative of character.

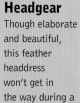

Jewelry

Ornamentation is both functional and decorative.

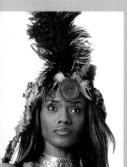

Headgear

Though elaborate and beautiful, this feather headdress won't get in the way during a fight.

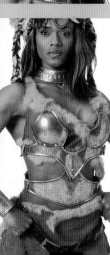

Armor

Necessary to protect her vulnerable midsection, this steel bustier also emphasizes her ample fantasy proportions.

three-quarter, back | **front**

Swordplay

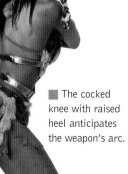

■ The cocked knee with raised heel anticipates the weapon's arc.

■ Suppressed energy waits to be released in the forward swing of the blade.

three-quarter, back | **front**

Death to the dragon

■ The downward thrust of the sword is imminent.

■ The warrior's bulging bicep testifies to the future force of the downward movement.

■ The sword is held tightly with both hands.

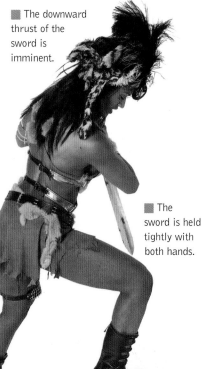

back

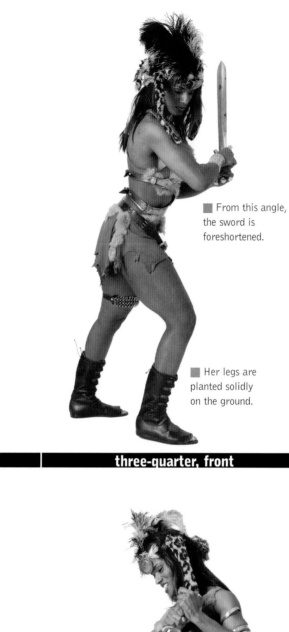

■ After the swing, the heel returns to the ground.

■ The back leg helps to maintain balance and pivot.

three-quarter, front

■ From this angle, the sword is foreshortened.

■ Her legs are planted solidly on the ground.

back

■ The back foot comes to rest flat on the ground as the sword pierces its target.

■ To add force, the heel is raised as the blade is brought down.

three-quarter, front

Making faces

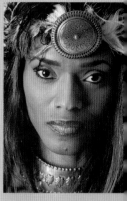

The eyes have it

When a character's expression is hard to read, look to the eyes to provide the clues.

Sudden anger

Note the narrow eyes, furrowed brow, and lips peeled back to reveal both the top and bottom rows of teeth.

Battle cry

In the act of yelling, the facial muscles get a workout. The chin drops, and the lips recoil into a grimace to push the cheek muscles upward and force the eyes into a fierce squint.

Classic poses

Preparing to swing
The warrior woman prepares to carry out a lethal blow. Her arm is held horizontally to balance the weight and swing of the ax.

■ The outstretched arm is used as a counterweight, to increase the force of the swing. Tension is held in the upper torso since the movement will come from the waist and shoulders.

■ The front leg takes the weight.

Don't mess with me
Here the facial expression amplifies the "don't mess with me" pose.

■ The heel is raised slightly.

Warrior soldier
This pose shows the warrior woman on duty and ready for action.

■ The warrior's expression is proud and serious. She is able to command or obey.

■ Her grip is assured and certain.

■ Her ax is held up as a warning, letting others know that it can cause a lot of damage.

■ Her arm is flexed with the veins apparent.

Sitting pretty

The warrior woman rarely relaxes. In this pose she is prepared to spring forward at a moment's notice.

▨ She captures and holds attention by her open, direct stare. She expects and gets respect.

▨ Her style of dress is contradictory. The feathers and animal skins suggest a barbaric society, but her armor, weapons, and decorations are of a sophisticated manufacture, so her culture is by no means a primitive one.

Resting but ready

This pose suggests swagger, even though the model is at rest.

Elven Warrior

It can be a challenge to depict the elves' dignity and inner strength, and to stress their nonhuman aspects, but it's well worth the effort.

Elves stand taller than the average human and have a slender, athletic physique. They wear their fair hair long and dress in a combination of cloth and leather, tending to avoid full armor unless necessary, relying instead on speed and combat skill to avoid injury. They are mainly on the side of good, although traitors and wicked examples of the elder race have been known.

The elves' weapon of choice is the bow and arrow. They are expert marksmen and can hit both standing and moving targets at long distance and in low visibility.

Vital statistics

Height:
6 ft 3 in. (1.9 m)

Chest:
40 in. (102 cm)

Waist:
32 in. (81 cm)

Shoe size:
8½ (8/40)

Your starting point

Slender and athletic
A distinction should be made between casual and passive poses. This is a casual one, because although he is standing still, the chest-out/ stomach-in stance, the haughty expression, and the hands on the hips give him a feeling of strength and command.

Anatomical studies

Beware
The arch of the body, along with the raised hands and body weight pushed backward, makes this a very defensive posture.

To arms, to arms
The thrown-back head and hands raised to the face emphasize the fact that he is calling the alarm. The legs placed wide apart give solidity and anchor the action.

The open fingers of the upper hand allow the elf to see the threat, while still giving protection.

From the front and the side

Front view

Kneeling and pointing the path ahead is a classic stance. The body is turned in relation to the position of the legs, and the pointing hand and arm align along the upper leg. The other arm and hand is positioned opposite the foot.

Side view

Note how the back foot flat on the ground gives the pose extra stability, and allows a curve to the upper body.

▮ The arms act as a counter to maintain balance at speed.

Into the fray

Running forward, the attention is focused on an object in the middle distance. The "push" of the body is on the front leg.

Let loose the javelins

To hurl a spear with a certain amount of accuracy the eyeline has to be fixed on the object and decisions need to be made in terms of distance and power of throw. Too much and it will miss, too little and it will fall short. The weight of the spear, known as the "heft," is gauged by the pressure on the upper arm.

▮ The leg on the side of the throwing arm is kept level.

▮ The distance of the throw is decided by how deep the bend of the opposite knee is. This will give a sudden rush of force as the body and arm are brought forward in the throw.

From the front and the side

Front view

This is a downward slice with the sword. The body is turned sideways to offer less of a target, and the resolute expression shows that the elf is brave and will stand his ground.

Side view

The posture taken confirms that he is an experienced and well-trained fighter.

Council of war

Here is another classic pose, with one foot up on a stool or rock, elbow resting on the knee and other hand relaxed on the hip, and an attentive look on the face.

Clothing the figure

Shirt and breeches

The white, full linen shirt has a decorated collar and cuffs. The breeches are moleskin.

Legs and footwear

Heavy leather tall boots are good for both walking and riding.

Wardrobe

The warrior's clothing is both elegant and practical. Various shades of green and brown predominate. Most elves live in the woodlands, and their clothes reflect this fact.

Cape

The heavy, unlined hooded traveling cape is fastened with metal clasp.

Armor

The suede leather cuirass is padded underneath for extra strength. Strips of leather protect the shoulders and allow ease of movement. Upper arm guards are attached to the cuirass, and there are matching vambrace (lower) arm guards. The guard on the left arm is longer than the right to prevent bowstring cuts.

side	back

Aim carefully

■ The elven bow is a lethal weapon, either shot singly or by the volley. This is a longbow, used for battle—shorter bows are also used for hunting. The impact of a bow depends to a great extent on its length. The first and second fingers of the hand draw the string back, and the arrow rests between them.

■ Here the elf has pushed the cape away from his right arm for ease of movement.

■ Hanging from a strap on his shoulder is a leather quiver of arrows, which would have extra pockets on the inside to hold spare drawstrings and tools for repairs and maintenance.

three-quarter, right	side, right

Following the path

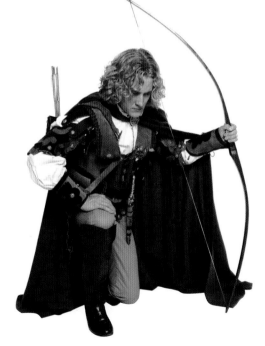

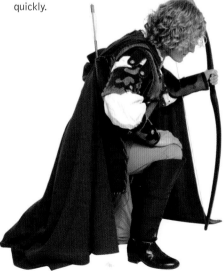

■ The quiver of arrows is slung loose and low so that he can draw one out quickly.

■ Elves are expert trackers, adept at following trails and scouting. This warrior elf is examining the ground, looking for evidence of those who have gone before. His bow is strung, ready for action.

three-quarter, back

■ The pressure is maintained on the left leg, while the right leg bends at the knee to vary the height of the shot.

front

■ The bow is aimed by sighting along the line of the arrow. The leather arm guards are not just decorative, they also protect the wrists from being cut by the bowstring.

side, left

■ The cape has been allowed to hang over the arm. This will prevent it becoming entangled if he has to stand up suddenly.

three-quarter, left

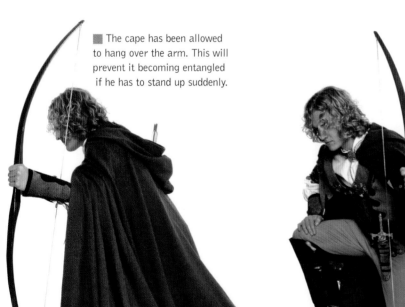

■ The bow is held away from the body for rapid use. The hand on the knee can be used for leverage to stand up.

Making faces

Elves are not demonstrative when it comes to emotions. They do feel love, sadness, and anger, but they tend to internalize them.

Solemnity

This is a typical elf expression. It could be considered passive, but there is a slight smile to the lips and kindness in the eyes.

Element of surprise

A look of surprise or shock is suggested by the wide eyes and open mouth, indicating a sudden intake of breath.

Troubled

The sadness in the face is here dictated by the downward gaze and lowered eyelids, and the tightening of the lips.

Battle cry

Full elven battle cry is demonstrated with the head back, mouth wide open, and eyes shut with effort. The chest is pushed out to enhance vocalization and add force to the cry.

Classic poses

Midnight fight

The elf is about to ambush his opponent. His cape is drawn up and over his head, and falls over both shoulders to mask his body and help him blend into the background. He is stealthily creeping up and carefully drawing his sword, and holds the scabbard upright in his other hand to make this movement easier.

■ The sword is carried high and the dagger low to be able to parry attack from any level.

Sword and dagger

In combat the sword allows both cut and thrust. The dagger can be used both defensively and offensively. For example, it can catch an opponent's sword, lock it down, and leave him defenseless, or it can be used to stab when the opponent is distracted by the sword blows.

■ The arc of the shoulder and bend of the knee show tenacity and resolve.

Take aim

Getting ready to shoot is sometimes called "nocking the bow." The nock is the part of the bow that the arrow rests on. Before taking aim and shooting the arrow, the bow is always pointed downward to prevent it letting fly too soon. The elf is considering his target and mentally measuring distance.

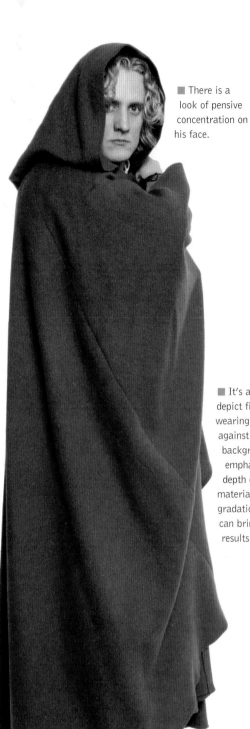

■ There is a look of pensive concentration on his face.

■ It's a challenge to depict figures wearing dark clothing against a dark background, but an emphasis on the depth of the folds of material and gradation in color can bring pleasing results.

Yours to command

This pose, and the look on the face, captures the proud and resolute nature of elven warriors. Do not confuse this with arrogance, which is purely a way of hiding fears that lay beneath. Elves do not lie and will never betray an oath.

■ The dagger, which is used both as weapon and tool, is worn on the left-hand side, next to the sword, to prevent it getting in the way of his bow arm.

Beyond the mountains

Elves' eyesight is far better than that of humans. They have a greater color spectrum and can see in the near dark. The elven warrior walks forward, shielding his eyes for a better view.

■ Note the way the bow is slung across the chest as an alternative to being carried.

I know their plans

As well as being good trackers, elves are expert at concealment. They can blend into the background, making use of shadow and darkness. Here the elf has returned from a spying mission. His cape is drawn around him, hiding his body. His hood is pulled up and he is holding the cape at the clasp to prevent it from flapping open.

Vital statistics

Height:
5 ft (1.52 m)

Dress size:
8 (10/36)

Shoe size:
8 (6/39.5)

Elven Queen

Elves, while looking human, are one of the elder races. They have a certain sense of superiority toward men; however, they also have some respect and paternal feelings for the human race.

Female elves dress in loose, flowing robes and prefer white, cream, and green clothing with gold and silver decoration. They have fine, delicate features, high cheekbones, thin eyebrows, and long hair.

It is important that the artist aims to emphasize the otherworldly feel and appearance of elves, with graceful movement and very mannered poses.

Your starting point

Graceful concentration

Female elves have a slender yet athletic physique. Although the stance here can be considered casual, the hands pressed to the forehead and the closed eyes denote concentration. The slightly raised left hip suggests arrested movement.

Anatomical studies

May the lords of light protect you

The elven queen is calling on the forces of good for help. Her head is tilted back as her eyes look upward, fixed in the middle distance to show that she is looking beyond the real world into another one.

■ The bent leg and arched body give off a sense of drama.

A shadow falls

This pose has plenty of tension, with one arm raised and fully stretched and the other drawn back to protect the face or avert the gaze.

■ The legs are wide apart, but the feet are firmly on the ground.

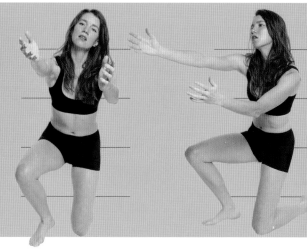

From the front and the side

My people need help

This kneeling pose, either beseeching or offering help, shows the use of the arms and facial expression to create drama. The main pivot of weight is on the left knee and hips, with the right shoulder brought forward as a counterbalance.

We mourn a hero passing

There is sadness here, both in the facial expression and the stoop of the shoulders.

■ The slight tilt of the head and forward bend of the right leg creates a sense of slow movement and quiet dignity.

I fear you not

This pose depicts the elven queen about to cast a protective spell. There is a look of firm resolve on her face and the out-thrust hand has an aggressive feel to it, while the other hand is held in a defensive manner. The distribution of weight on the hips and angle of the right leg add power to the stance.

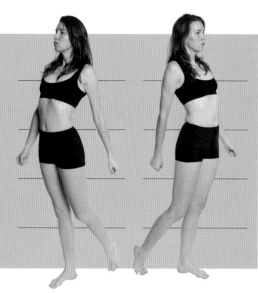

My lords and ladies

The queen is greeting courtiers and comrades. Her expression is serious, yet welcoming. She moves forward in a graceful manner, with both arms out in greeting.

■ The hands and fingers are relaxed.

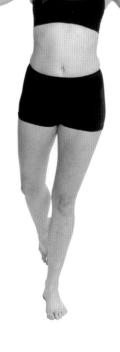

From the left and the right

Come forth, my paladins

The elven queen is striding forward to review her warriors. The stride is graceful and stately, but the clenched fist betrays her worries about the battles to come.

Clothing the figure

Undergarments

Under her dress the queen wears a simple white linen chemise and petticoat.

Wardrobe

Elves wear light, loose, layered dress in pale pastel colors. Velvets are common, and traveling capes and cloaks are worn when outdoors. The look is simple yet elegant.

Belt and girdle

A decorated rope belt is worn slightly below the bust, and a metal girdle belt is worn on the hips.

Footwear

The decorated slippers denote status—delicate shoes are not suited for outdoor or heavy use.

Jewelry

The queen wears engraved silver wristbands, and a simple metal torque around the neck. A metal diadem with polished stones is worn on the forehead, with the hair pushed back from the face.

front	side

The potion of truth

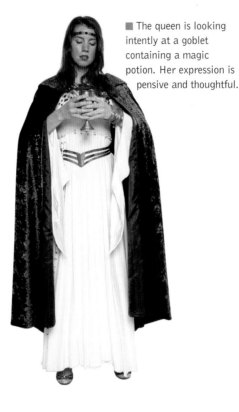

■ The queen is looking intently at a goblet containing a magic potion. Her expression is pensive and thoughtful.

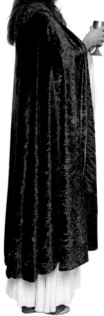

■ The side view shows how the cape rests on the shoulders.

three-quarter, front	front

Arise my liege

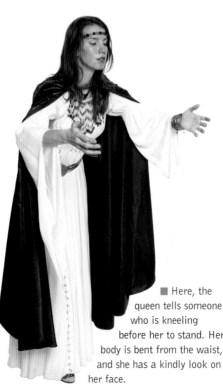

■ Here, the queen tells someone who is kneeling before her to stand. Her body is bent from the waist, and she has a kindly look on her face.

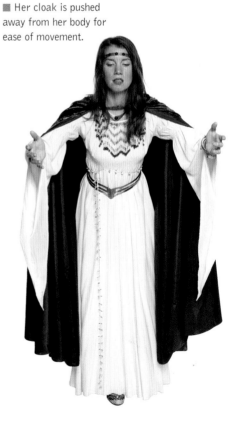

■ Her cloak is pushed away from her body for ease of movement.

back

■ The rear view gives a feel of the weight of the cape, and shows how the material falls into pleats that complement the lighter material of the dress.

three-quarter, front

■ This view shows how the cape and sleeves hang. It also shows how the hair falls, kept away from the face with a headband. The goblet is held close to the body to emphasize its precious contents.

back

■ The rear view shows the fall of the cloak. The arm position creates a leveling of the material.

side

■ Here we can see how the long sleeves fall. The right foot forward compensates for the position of the arms and upper body.

Making faces

Elves are beings of magic—inhabitants of Faerie. They have an ethereal quality to them that should be emphasized in any depiction.

What is before us?

The elf queen has a reflective and wistful expression—seeing both the past and into the future.

A gentle spirit

The downward and contemplative look on her face shows that she is capable of great acts of kindness.

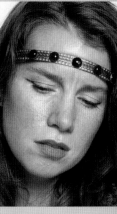

I sing in the dawn

The elves are great musicians and singers. Their songs and chants are legendary, and humans can never hope to equal their skill with words or their vocal range. Here the queen is chanting the ode to the breaking day while watching the sun rise.

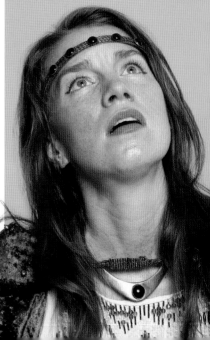

Classic poses

Farewell and good fortune

The queen is indoors, so she is not wearing her cloak. She gazes into the middle distance, with one hand resting on her hip and the other holding the hem of her dress up for ease of movement.

■ Movement of the dress gives an impression of ethereal, enchanted material.

Return to us safely

A similar pose to the previous one in terms of body position.

■ The raised arm complements the position of the other arm.

■ The use of the cape in this pose gives a sense of solidity and a feeling of contained power.

Get back hordes of chaos

Here the body is held back, with the front leg straight and firm on the ground. The cloak is held up as protection.

Please drink

The cloak is again pushed back, and the straight arm holding out the goblet conveys drama. The position of the other hand gives the pose authority, and the expression on the face is persuasive.

I beseech you

Although down on her knees, this pose is not submissive.

■ The expression on the face is one of sorrow, not fear.

I am queen, I command

The firm stance, slight twist to the body, and assertive expression show that the queen demands respect.

I call on the fates

This deferential pose, with both knees on the ground, arms raised, and an upward gaze, implores help from the higher powers.

Vital statistics

Height:
5 ft (1.52 m)

Bust:
33 in. (84 cm)

Waist:
26 in. (66 cm)

Shoe size:
7 (5/38.5)

Fairy

Fairies are the archetypal denizens of the realms of Faerie. Their appearance is mainly feminine, although males do exist, and they look very young, although they can be hundreds of years old. They are very direct in their emotions, and will pass from one mood to another in an instant.

Fairies have the ability to fly on thin gossamer wings, and their speed and small size mean they can easily hide if they do not wish to be seen. Although intrinsically good, fairies do have a fine sense of mischief and often play (relatively) harmless pranks on unsuspecting or deserving humans.

All of these characteristics give the artist great scope for depicting flight, relative scale, and romantic or amusing scenarios.

Your starting point

Weightlessness
The fairy is often depicted in flight, and the artist should employ a lightness of touch to reflect this.

Anatomical studies

■ The tension in the stomach and shoulder muscles helps to show the sensation of "lift."

On mossy bank
This pose suggests that she is resting. It could be against a tree, bank, stone, toadstool, or similar. The way her head is resting on her hands is both childlike and feminine. Her legs are taking most of the strain, and the turn of the shoulder is relative to the hips, allowing the position to be maintained with comfort.

Taking flight
Here the fairy is just about to take to the air. The position of her arms, her raised leg, and her tiptoe stance all combine to give a feeling of weightlessness, as if there is a current of air beneath her that will help raise her up.

From the front and the side

The pretty moonbeam

In this pose the fairy is allowing something to pass through her hands while she studies it with a wistful look on her face. She has cocked her head to one side and moved forward to get a better look.

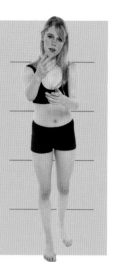

■ The position of her hands and arms suggests that she in not actually holding the object, but instead letting it run though her hands

Catch me if you can

Although flying away from a pursuer, the fairy probably has every intention of being caught in the end. The happy look on her face shows that she is not frightened, nor is she fleeing from danger.

■ Her sightline follows the line of her arm to the hand, which is beckoning someone to follow.

Buttercups and bluebells

Kneeling to pick wild flowers to make a garland, the fairy's attention is focused on the ground before her, deciding which blossoms will look the nicest in her hair. The top half of the body is resting on the upper leg, with the arm providing extra stability. This pose also shows how petite she is.

Away, away

The fairy has been panicked by someone or something and is about to flee. There is a look of fear and trepidation on her face, although with fairies it is difficult to gauge the level of the threat—because of their temperamental nature, it could be a raging troll or an angry owl.

From the front and the side

Catch the butterfly

Another pose in flight, this time the fairy is attempting to catch something in mid-flight. Her attention is determinedly fixed on the object before her. One arm is stretched out, trying to grasp, while the other helps her to maintain balance.

■ The movement of the hips determines the bend of the knee and position of the shoulders.

Clothing the figure

Ethereal qualities

Fairies do not wear costumes in the accepted sense. Instead it should be difficult to ascertain where the clothing ends and the fairy begins. Fairies are creatures of light and air, and the way they dress reflects this. Very thin, light, multicolored fabrics in rainbow hues can be decorated with flowers and wisps of gossamer, all to give an ethereal feeling. The artist should aim for a translucent, lightweight effect, particularly in the treatment of the diaphanous fabrics and gossamer wings.

Footwear

Simple, open-toed sandals have cross-strapping to just below the knee.

Wrap

The gauzy shoulder wrap is made from cobwebs or the like, and decorated with flower petals and leaves.

Wings and garland

Thin, transparent wings enable her to fly and glide on the wind, and a garland of woodland flowers is worn in her hair. Remember that she is a tiny creature with quick, precise movements.

Lords and ladies

front

■ Kneeling down to greet the rulers of Faerie, our heroine has a serious look on her face and is respectful but not subservient.

back

■ The weight of the body is taken on the knee and leg, with the leg held straight out behind her to help maintain balance.

I won't go in there!

three-quarter, right

■ Suddenly backing away in mid-flight, the fairy has seen or felt something frightening.

side

■ The upper body is drawn back. The arrested momentum has kept her leg forward, and the forward arm acts as a counterbalance.

side

▓ The wrap is held away from the body to prevent it trailing on the ground, and to ensure that it won't get in the way when she stands up.

three-quarter, front

▓ The open arms show that she welcomes the attention and has nothing to hide.

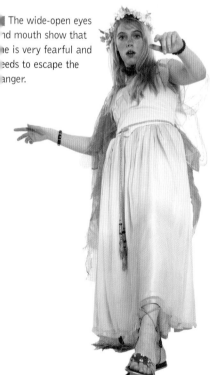

front

▓ The wide-open eyes nd mouth show that e is very fearful and eeds to escape the anger.

three-quarter, left

▓ The position of the arms adds to the drama of the pose, and the placing of the upper arm and hand draws attention to the face.

Making faces

When depicting expressions it should be remembered that, as well as being like children in their physique, fairies are also childlike in their emotions. Their faces reflect their feelings and they make no real attempt to hide them. They laugh when happy and cry when sad, with little in between.

What's that?

This look, with the cheeks pulled in, the mouth in an "O," and wide eyes, conveys surprise rather than fright.

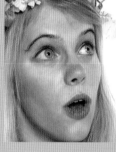

A new trick?

The naughty little smirk and far away look probably mean she is thinking of mischief. A good clue to what someone is feeling can be conveyed by the shape of the mouth and lips. There is genuine amusement in this expression.

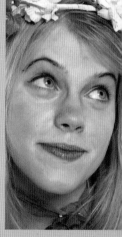

Fun and games

The fairy is shrieking with delight. Although her mouth is wide open, the upturned corners show that this is an enjoyable experience. The raised eyebrows also denote excitement—by contrast, when threatened or angry, the brows draw down and press upon the eyelids.

Classic poses

Fly free
The actual size of the fairy can be ascertained by reference to the butterfly she has released from her hands.

Down in the dell
This pose gives a good view of the fairy's wings. Turning toward the viewer, her left hand draws the eyes in, which then follow the line to her face, then on to her pointing hand.

■ The turn of the upper body and raised foot enhances the pose.

■ The angle of the material shows the direction of the wind and the swiftness of her movements.

Soaring away
The way the wrap and dress flow out from behind her shows that she is flying at speed, and the upward gaze and position of the hand reinforces this sensation.

Dancing in the dawn

Here the fairy dances with wild abandon. Her arms are thrown out, her shoulders are back, and her body is tilted at the hip.

I am your servant

In a curtsey position, the lowered head signals a mood of submission to a higher authority.

■ The motion of the dress embellishes her nimble movements.

■ By holding the dress up and away from the feet, this movement can be made gracefully.

A gift for the queen

Bending down to pluck a flower, this pose is elegant and graceful. The delicate way she holds the flower by the stem creates a wistful feeling.

Fond farewell

As she leaves, the fairy turns to say good-bye. There is no sadness in the gesture because it is not in her nature to be gloomy or unhappy. Her eyeline tends to be directed upward, since in relation to other fantasy characters she is the smallest in terms of size.

■ A happy and joyful expression is emphasized by the head tilted toward one shoulder.

■ The way she holds up her gossamer wrap suggests upward movement, as if she is about to fly away.

Lords and ladies

The fairy curtsies to the rulers of her realm, moving gracefully and with ease. However, because of her nature, there is a hint of playfullness in her manner, which implies that she doesn't take anything too seriously.

■ The position of the body is indicative of sustained momentum.

■ The movement is being made from the knees, and is more of a dip than a bow.

Moon gazing

Wistful and lost in thought, the fairy gazes at the reflection of the moon on the water. Her expression is contemplative but not regretful. Something might easily distract her, since her attention span is very limited.

■ With relaxed shoulders and arms her wings are more obvious.

Spell weaving

Using her magical skills, the fairy crafts an enchantment. Fairies will grant wishes and cast spells for others, but their mischievous nature means that often the conjuring will have unexpected results.

■ The use of hand gestures is important. Effects such as glowing lights emanating from the fingertips make a more visually arresting image.

■ The lightweight material of her dress moves easily, giving a real sense of motion. Deep folds of material can help to give depth and form to portrayals of various magical characters.

No, no, no

The wide eyes, raised eyebrows, and wagging finger show us that the fairy is busy scolding someone. She is childlike, but not childish. The difference is important. Fairies would never allow anyone to come to real harm, and will side with the forces of good over evil. Fairies can act like spoiled children sometimes, but underneath it all they are not malevolent and should be considered as agreeable and amusing individuals, if a little naughty sometimes.

■ The deportment of the body accentuates the petulant nature of the gesture.

On mossy bank

Even fairies have to sleep, and here our character relaxes and dreams of further adventures. Again her delicate and ethereal nature is stressed by the archetypal sleeping position she has adopted. Her face is relaxed, although there is a little smile on her lips.

■ The way she lies is graceful. The knees are drawn up, and the body language is still and calm.

Vital statistics

Height:
5 ft 3 in. (1.6 m)

Bust:
34 in. (86 cm)

Dress size:
6 (8/34)

Shoe size:
6 (4/37.5)

Princess

The princess is haughty, proud, imperious, and a little spoiled. She is used to her commands being obeyed without question, and finds it difficult to accept criticism and contrary opinions. However, it must be stressed that it is not her sole function to be rescued at the last moment by the hero. She should be able to instigate action for herself and deal with most situations. She must be depicted as an individual, not merely an ornament or accessory for the hero, or as set dressing.

The model here has a slim, elegant build; she is well proportioned and graceful, and carries off the demeanor well.

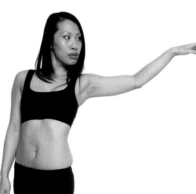

Your starting point

Anatomical studies

■ Her arched back and thrust-out bust and hips give an imperious feel to the pose.

An easy life

The princess is usually depicted in her late teens or early twenties. She has had a cosseted, pampered life, and there should be a suggestion of indolence and easy living in the way she moves and reacts to a situation. The model here has an athletic build but is not too muscular. She has good posture and poise and carries herself well.

An accusing look

The slightly dismissive hand gesture and the languid turn of the body sum up the attitude and personality of the princess. The weight of the upper body pivots on the bent leg, and the relaxed raised arm and hand give the impression that the princess can be lazy and indolent, even when giving commands.

Into the throne room

As the princess enters the throne room her pace is leisurely yet precise. Her slightly tilted head and quizzical expression show that she is used to being the center of attention.

▩ The sightline is fixed on one finger of the raised hand.

From the front and the back

Temple dancer
This is a very useful dancing pose. The movement of the arms is complementary to the leg positions, and the angle of the hips shows the direction of the movement of the body.

The weight is being taken on the toes and the arch of the foot. Careful positioning of the arms can make the pose much more expressive.

As the sun rises
The princess is also a high priestess of her religion. Here she greets the rising sun. The whole posture is one of reaching out toward an object. The taut stomach muscles show the physical effort put into the pose.

▩ The bend of the leg and raised foot accentuate the upward impetus.

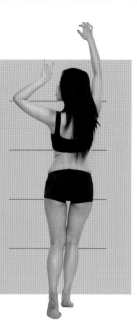

Early morning
The princess has just awoken. She is stretching her body while walking forward toward her attendants, who will groom and dress her. There is an easy grace and movement in the pose.

Dragon bait
The princess cowers back in terror as she is attacked from above. The leg folded back acts as a support, and allows the upper body to bend back while the hand and arm support the weight, since the other arm is raised protectively. The other leg could be used to push herself away from the attacker.

From the front and the side

Midnight abduction
Here the princess has been disturbed by kidnappers intent on carrying her away. She looks frightened, but is not begging for her life. Her body is arched away from the object of threat, with a slight turn of the waist to emphasize the action. Her

hands are raised to her face in a defensive gesture, but could also be pushing something away. The position of her body suggests that she has risen up from lying down, rather than having fallen to her knees.

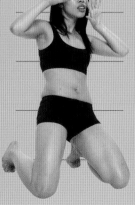

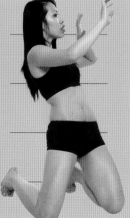

Clothing the figure

Wardrobe
The princess dresses in ornate and extravagant costume. Lots of gold brocade, decoration, and ornamentation make her wealth and rank obvious. A gold bustier wrap is worn with a beaded and sequined girdle with attached skirt and ornate apron. She wears a lightweight, burnt gold overrobe and soft silk slippers, since she need not do much walking.

Ornamentation
The decorated shoulder and chest piece helps make the princess look more imposing. It has a separate collar with metal bosses and precious stones.

Handwear
The metal bangles and painted fingernails show that she does not have to undertake any heavy work; it's all done for her.

Headdress
An elaborate headdress with gems and peacock feathers has the effect of making the princess appear taller, and causes the gaze of spectators to look up to her, increasing her importance and giving her a commanding attitude.

front

An arrogant dismissal

■ The princess orders someone out of her presence, the sweeping gesture of disdain emphasized by the flow of her overrobe.

side, front

■ The purposeful stride forward with the head turned toward her object of scorn confirm that every command will be obeyed.

three-quarter, front

Entreat the gods

■ Her weight rests on her folded leg, and her upper body is arched back slightly to allow her gaze to travel upward.

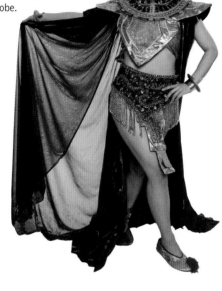

■ Kneeling before an idol, the princess begs for supernatural aid or protection.

back

■ Her overrobe has fallen back from her shoulders and creates a framing device for her torso, while her skirt has been draped around her, making it easier for her to stand up.

back

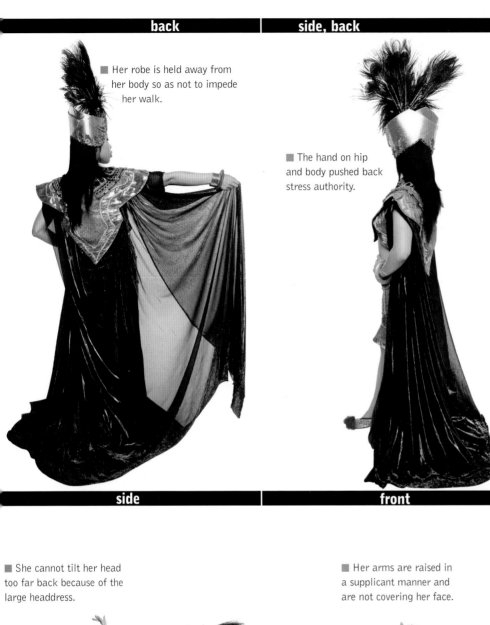

■ Her robe is held away from her body so as not to impede her walk.

side, back

■ The hand on hip and body pushed back stress authority.

side

■ She cannot tilt her head too far back because of the large headdress.

■ The outstretched leg gives the pose an elegant and mannered feel.

front

■ Her arms are raised in a supplicant manner and are not covering her face.

Making faces

The princess should have the full range of expressions. Unfortunately, the one that comes easiest to her is a condescending sneer. However, once her cosseted way of life has been threatened, or her life placed in danger, she will become more human and approachable.

Perhaps I'll trust you

Here the princess has allowed her guard to drop. The thoughtful look and head at a slight angle show that she is attentive and willing to listen.

Heartbreak

Because of her luxurious and indulged lifestyle, the princess finds it difficult to deal with misfortune. Reacting to bad news, she lowers her eyes, her shoulders relax, and she tries to fight back the tears.

You dare contradict me!

Here the spoiled little girl shows through the regal mask. A contrary opinion has her losing her cool.

Classic poses

I am a daughter of the sun god

Here the princess stands in a commanding and domineering attitude. The chin is tilted upward, so that anyone interacting with her would have to look up to her, increasing her sense of status.

■ The arms folded across the chest indicate resolve and a willful manner.

■ The bent leg also suggests that she is about to collapse in a faint.

Palace intrigues

Sitting on her throne, the princess overhears a plot and listens intently before deciding what action to take. The crossed legs and relaxed shoulders suggest she is at ease, however the chin resting in the hand and the furtive sideways look show that this is not so.

■ The lightweight material of her overrobe models the shape of the throne and creates very interesting folds and shadows.

■ The closed eyes and downward droop of the lips add to the emotion. The loss of her headdress effectively diminishes her status and makes her less imposing.

Ill tidings

Receiving bad news, the princess allows her demeanor to collapse and reveals the person underneath. Her drooping shoulders and generally dejected attitude are reinforced by the position of her hand on her brow and the way she is about to drop the scroll from her other hand.

▧ With eyes raised heavenward, her arms are held out in a humble yet assertive stance.

Temple dance

As high priestess of her gods, the princess must lead the celebrations on holy days. Here she is performing a dance in honor of the gods.

Oh hear us, our gods

The princess will only demean herself to those she considers her superiors, and shows reverence and respect to her gods, placating their whims.

▧ Her twisting body and swirling fabrics create a dramatic sense of movement and energy.

▧ Her legs are together and her body is tense with trepidation.

In the dungeon

Captured by the forces of darkness, the princess has been thrown into a prison cell and nervously awaits her fate. She is hunched up, trying to make herself small and insignificant. Her frightened and wide-eyed expression illustrates that she is no longer in control and is finding it difficult to cope with the situation.

▧ The direction of her head could indicate that someone has entered the room and is standing behind her.

▧ The position of her hands suggests that she has been weeping.

Wicked Sorceress

Villains can be by far the most interesting characters to depict, with great scope for dramatic poses, expressions, and lighting effects. The wicked sorceress is an irredeemable foe of the forces of good. She is a servant of chaos and will use any means available to achieve her ends. The dramatic use of costume, props, and gesture involved in depicting her can be very satisfying to work with.

Vital statistics

Height:
5 ft 4 in. (1.62 m)

Dress size:
8 (10/36)

Shoe size:
7 (5/38.5)

Your starting point

Expressive hands

The hands are important for this character and cannot be overemphasized. Arms fully raised and head thrown back, the sorceress is using her powers to place a curse. The tightness of the stomach muscles shows the amount of strain and effort needed to generate tension in a purely standing pose.

Anatomical studies

■ One arm and hand is pushed out in a gesture of power, the other is bent back, mirroring the position of the leg and body.

Away, away

The posture here is total action. Weight is carried on the bent leg while the forward leg is used for support.

On your knees

The haughty expression on the face and the downward pointing hand evoke a feeling of power and control.

From the front and the side

Arise wraiths and specters

This position shows the sorceress leaning over a caldron or altar, calling up the evil dead. The full stretch of the arms and the open but tensed fingers give a good indication of the effort being put into the evocation.

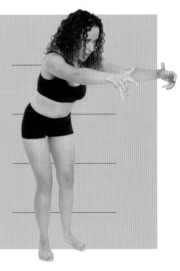

The body is bent over to focus attention, and the slight bend of the legs acts as a counterbalance.

Prepare to suffer

The sorceress has an almost feral look to her. She is about to spring forward and physically attack someone.

Heed thy supplicant

Although the sorceress is in a submissive pose—kneeling with her body resting flat on her raised thigh, arms out to the side with hands palm down—there is a crafty and cunning look on her face. This lets you know that, although supplicant, she is in control of the situation.

I shall have revenge

After the invocation, the posture changes slightly. The arms bend in at the elbows as she prepares to rise.

From the front and the side

Back, back I say

The sorceress is backing away from a threat. Her hands are up and pushing away while her body moves backward, away from the source of attack. There is a look of fear on her face, but this is tempered by the innate arrogance she possesses.

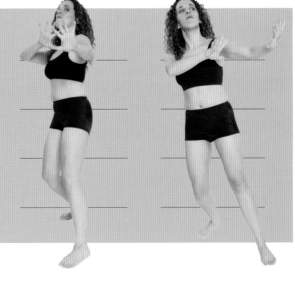

Clothing the figure

Underdress
A well-fitting, sleeved satin underdress features detailing on the cuffs.

Footwear
The sorceress does not spend a lot of time outdoors or riding, so decorated slippers suit her needs.

Dress
The dark blue velvet tabard dress has long, hanging sleeves.

Waist belt, amulet, and neck torque
The pattern on the belt matches the torque.

Cloak
The satin, hooded cloak has an added fur collar for warmth.

Wardrobe
The sorceress dresses in layered clothing, with cloaks and jewelry adding to her sense of status. Try to avoid the temptation to dress your villains all in black; it can become something of a cliché. Dark colors do add mystery, but lighter shades help to break up the tones and can create interesting effects.

three-quarter, front | **side**

Yours to command

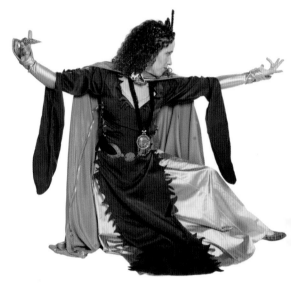

■ The sorceress is turned sideways, with her center of gravity focused on the spine. Her weight rests on the back knee, and her arms are used to gesture.

■ The sightline follows the line of the arm and finger. The pointing finger on the other hand draws attention back to the face and the opposite hand.

three-quarter, front | **front**

What the future holds

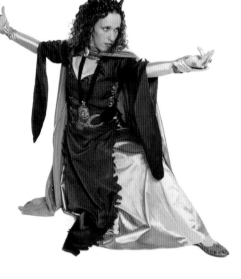

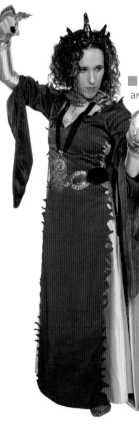

■ The sorceress's eyes are fixed on a crystal ball as she tries to foretell her fate. The shoulder and arm of the hand holding the ball drop slightly, showing that the ball has a certain weight to it.

■ The pointing finger draws attention to the ball.

back

■ The back view shows how the cloak hangs and how the creases of the satin material catch the light.

front

■ Note the level of concentration on the face, focused in on the outstretched hand. The sorceress uses her hands to cast spells, so this part of her anatomy cannot be overemphasized.

back

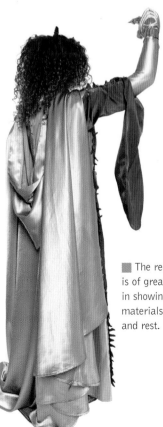

■ The rear view is of great use in showing how materials fall and rest.

side

■ Particular attention should be paid to the facial expression and the way the hand grips the crystal ball.

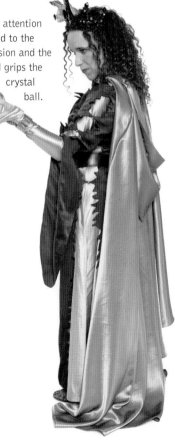

Making faces

The sorceress is adept at meeting the viewer's stare with an unflinching intensity.

All in the eyes

The eyes of the sorceress are important. She should combine arrogance with a furtive mistrust of everyone else.

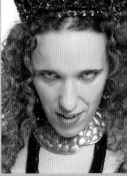

Vindictive rage

The drawing down of the mouth and eyes emphasizes her rage and anger.

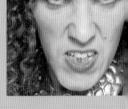

Plotting

Thoughtful and pensive—what evil ideas are going through her mind?

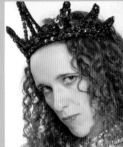

Evil chants

The sorceress uses spells and chants to gain and maintain power. The wide open mouth and eyes, with the whites showing above the pupils, give a strong and forceful appearance.

Classic poses

■ The hands are almost clawlike, and the face is fixed into a snarl.

I will rend your soul

Here she is crawling up on a victim, her catlike nature coming to the fore.

No one betrays me

Although adept at magic, the sorceress is not averse to using weapons, should the need arise. She carries a dagger hidden about her person at all times. Here she is just about to use it, and probably enjoying the moment.

Flee the dawn

The sorceress is using her dark powers to fly away.

■ The use of extreme gestures, expressions, and posture accentuates the otherwordly aspect of this character.

■ Her cape billows out behind her as she levitates.

■ Although the face cannot be seen, the emotion of the pose is sensed through the tensed pointing fingers.

Do not forsake me

This pose can be interpreted as a request for aid. The beckoning gesture is made more powerful by the way the cloak is being held, giving the stance a feeling of solidity, fixing it to the spot.

No remorse

The dagger has been plunged. A life has been lost. The sorceress tastes the blood of her victim.

This is my domain

The sorceress has just materialized. Her cape billows out before her and gives a fantastic sense of movement and drama.

■ The highlights on the fold of the cape complement the deep shadows and give the material a fluid, almost living feel.

Vital statistics

Height:
6 ft (1.83 m)

Chest:
44 in. (112 cm)

Waist:
31 in. (79 cm)

Shoe size:
9½ (9/44)

Warrior Prince

The warrior prince is also known as a paladin, an officer of the palace and a heroic champion. Paladins are brave, virtuous, and kind. They protect the weak and punish the wicked, and are sustained by a belief in the justice of their cause. Their word is their bond and they will never knowingly break a pledge.

Noble, valiant, and strong, the warrior prince is the most powerful non-magic character in the fantasy world. He is tall, broad, and muscular, and for the artist the challenge is to epitomize both his fighting skills and his aura of nobility.

Your starting point

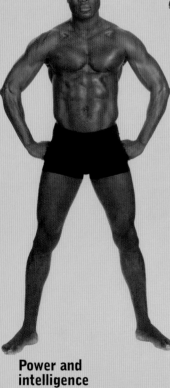

Power and intelligence

The prince has a very powerful, athletic physique. His broad shoulders, well-defined chest, and stomach, plus strong leg muscles, confirm that he is no stranger to physical action, but he also has a thoughtful, intelligent face.

■ The prince's gaze is fixed on the fingertips of his outstretched arm, which helps him to measure distance.

Anatomical studies

Javelin throw

Preparing to throw a spear, the prince shifts his weight to allow his body to curve back in relation to the forward bend of the leg. This creates the impetus necessary to produce a powerful throw.

■ The arch of the back allows the center of gravity to be maintained on one knee.

■ The lowered arm can be tensed and pulled in to help maintain balance.

I swear to be so

This is a well-balanced, formal kneeling pose, and the angle of the arm and head, combined with the raised instep, signifies that it is not a submissive posture.

From the front and the side

Palace exercise

On waking, the prince exercises in the courtyard. This pose allows the artist an excellent opportunity to study the chest and stomach muscles and how they move in relation to the hips and legs.

■ The look on his face shows his will to win; he will be a tough adversary.

■ People with dark skin have lighter colored palms and soles of the feet.

■ Muscle tension is contained in the chest and shoulders.

Cease and desist

With a purposeful step, the warrior prince seeks notice and requests obedience. The lowered head, forward curve of the torso, and hand raised at chest level show that he is seeking to calm and pacify, rather than command and order.

Wrestling bout

With feet firmly fixed on the ground, the prince makes ready to grapple with an opponent. His whole body is taut, with the main areas of tension visible in the arm, shoulder, and calf muscles.

Give me your blessing

This is a more submissive kneeling pose than the one below. The low curve of the back and lowered head suggest vulnerability, and the downward look of the eyes also evokes a feeling of defenselessness.

■ The character's center of balance is evenly distributed between the upper and lower leg.

I have found the amulet

The prince bends forward to retrieve an object, so his center of balance is focused on his shoulders and knees. The strain shows in his neck and shoulder muscles, and the definition of his arms is especially obvious.

■ The open fingers and intense expression augment the pose, giving it more emotion.

From the front and the side

Take the strain

This pose could be used as a defensive posture, with a shield and sword. It could also be a pulling pose, because the stress is placed on the legs to move forward while the arms are held back in the opposite direction.

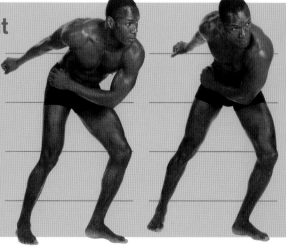

Clothing the figure

Undergarments

The prince wears clothing that confirms his status as being of royal birth. Rich colors, decoration, and plenty of gold are evident. Beneath his robes he wears simple cotton knee breeches, worn loose for comfort. On his legs he wears painted leather, booted sandals.

Tunic

A loose, square-cut tunic features detailed embroidery. The lightweight material indicates that he resides in a warm climate.

Symbols of rank

A gold medallion and beaten metal wristbands display wealth and rank, but are not too ostentatious.

Armor

The toughened leather cuirass with embossed metal plates is both decorative and practical.

Ready for combat

The whole look is finished off with a brass helmet featuring a large crest. Around the helmet a diadem is worn, displaying the prince's rank. The short stabbing sword is worn to the side, hanging from a baldric (shoulder strap), while a gold cape is worn for traveling and identification.

side, right | **back**

Defending the battlements

■ The prince uses his shield to deflect blows, while making ready to counterattack.

■ The shield is held flat out, offering maximum protection to the upper body.

■ The prince's armor safeguards his torso while allowing for easy movement of both the sword and shield arms.

■ Keeping the lower leg off the ground enables the prince to rise quickly and move backward and forward, depending on the ferocity of the attack.

side, right | **back**

Fatal thrust

■ The prince is using the short sword like a dagger, to stab rather than to slash, since a stabbing blow is usually deadly.

■ The leather strips of the tasset skirt attached to the body armor allow the warrior to move freely.

■ The shoulder guards are attached to the chest piece with flexible leather ties that let them move in relation to the arms.

■ The back leg will act as a lever to push the upper body forward and downward.

side, left

▥ The shield is kept below the eyeline to allow the prince a clear field of vision.

▥ Having the sword on a shoulder sling makes it less likely to get in the way.

three-quarter, front

▥ The combination of helmet, large shield, and greaves (leg guards) creates a highly effective barrier to an attacker.

▥ The greaves are designed to give maximum protection to the shins, while still permitting movement at the knee and ankles.

side, left

▥ Note how the weight of the sword scabbard brings it forward, away from the body.

▥ The lower arm acts as a counterbalance and is also well positioned for grabbing and holding.

front

▥ The gaze is intently fixed on the target of the killing blow.

▥ The whole dynamic of the pose is emphasized by the downward angle of the sword and the position of the head. The deep knee bend gives the posture extra power.

Making faces

The challenge in depicting the warrior prince lies in bringing out his innate nobility and dignity while allowing him the full range of emotions.

Trust me

The direct stare shows that the warrior is being truthful and resolute. Looking straight into the eyes implies honesty.

Deliberation

In pensive moods a person becomes self-absorbed. A downward gaze and the stroking of the chin are good visual clues for this.

Joyful day

Smiles and laughter can help create a fully rounded personality. All characters should be able to feel elation and happiness.

Forward the guard

The design of the prince's helmet enables his face to be protected while allowing his features to be seen and voice to be heard. It makes the prince identifiable on the field of battle to both friend and foe alike.

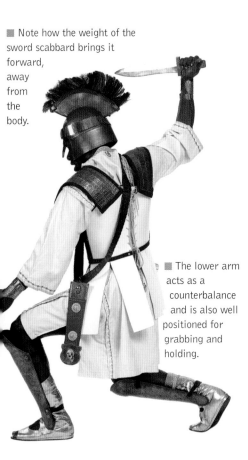

Classic poses

■ The lack of a cape or helmet suggests that the character is indoors.

So, tell me your plans
The prince treats everyone with respect. He will listen to the opinions of others and will not prejudge. This relaxed pose shows that he is at ease in his surroundings; however, he is still wearing armor and weapons, so battle may be in the offing.

■ His demeanor is attentive and thoughtful. He will take everything into account before making a decision.

Do not question my honor
The prince's honor has been questioned, and with a stern expression he demands an apology. To draw the sword, the scabbard must be held away from the body, to enable it to be withdrawn quickly and prevent it getting caught in the clothing.

■ He wears his short animal-skin cape as an identifying device, so that his own troops will recognize him.

It's well defended
The hand shading the eyes draws attention to the warrior's face and the direction of his gaze. The prince scans the horizon, taking stock of the enemy and their numbers before deciding on the next course of action.

I am honored to greet you

In his role as heir to the throne and diplomat, the prince welcomes visitors to the royal palace. He makes an impressive figure dressed in the full court regalia. Because he is in his own surroundings, there is no need for him to wear armor or carry a weapon.

■ His bow is low enough to show respect without being subservient.

Sitting in judgment

His dignified expression and upright bearing show that the prince takes his duties seriously. By wearing armor he invokes and represents the authority and power of justice and law.

■ His body armor helps him maintain a rigid posture.

■ The gold cape shimmers in the light and makes the prince look broader and taller.

■ Sitting with the legs apart allows the tunic and tasset skirt leather strips to rest flatter, and looks more decorous.

Vital statistics

Height:
6 ft 1 in. (1.85 m)

Chest:
42 in. (107 cm)

Waist:
38 in. (96 cm)

Shoe size:
10½ (10/46)

Wizard

Wizards are usually depicted as being elderly and bearded, wearing long robes consisting of several layers. They are not physically powerful in terms of musculature, but the artist needs to emphasize wisdom and resolve in the facial details and power in the positioning and stance of the body, particularly in the execution of the hands, which are used to cast spells. The model featured here, although mature, is still very active and could, if need be, hold his own in a sword fight.

■ The emphasis is mainly on the eyes and face.

Your starting point

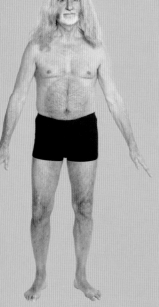

Anatomical studies

The path ahead
Here the wizard is moving forward. His weight is on the right leg and his shoulders are slightly arched, to give a dynamic feel to the gesture.

Dignified wisdom

This pose is a good example of how a character would move beneath many layers of clothing. The arms are out from the sides to take into account the weight of the costume. Although it is a fairly relaxed pose, there is still a sense of the forceful strides that the wizard would take.

■ This is a different angle of the forward-moving pose, but it shows how even a relatively simple stance can create a strong image.

From the front and the side

Magical movement

Here the wizard is conjuring up an object. Although his pose is casual, with his body weight evenly distributed, there is a look of concentration on his face, and the tension in his hands is important.

■ The tension is centered in the shoulders and hands.

Invoking the spirits

This character shows drama in the stance, not the action. Here, with arms raised up and out, his weight is carried on the heels.

Get back

This is a great pose for a magician, either forcing back evil spirits or calling forth supernatural aid. The hands are splayed out to give exaggeration to the gesture.

■ This is a more defensive variation on the conjuring position, due to the lower and more turned-in position of the arms, combined with the straighter legs.

■ The right leg is slightly bent, with the weight on the left, giving the impression of resolve and determination.

From the front and the side

It is written

Movement here is from the waist and the hip. To allow the character to retain dignity and maturity, try not to use postures that are extreme.

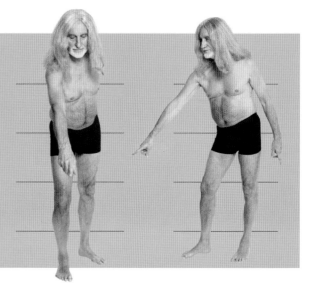

Clothing the figure

Wardrobe

Above a simple cotton underlayer, wizards wear many layers of heavy clothing. The clothes denote status, but the simple, plain style and colors also signify that the wearer is unconcerned with worldly wealth.

Top layer

The wizard wears a plain-colored woolen shift and matching tabard, with a simple leather waist belt, and carries a traveling pouch.

Ring

A magic ring of power is worn on the right hand.

Amulet

Magic amulets give added protection.

Sword, scabbard, and belt

Wizards can also fight with standard weapons, if need be. Note the potion bottle hanging from the belt.

Hat and cloak

The tall, pointed hat and heavy cloak give added status to the wearer, and make him more imposing.

front | **side, left**

Casting the spell

■ The arm is out in this dramatic pose, with a finger pointing at an opponent. The foreshortening of the pointing arm adds to the power, and the cloak is pushed away from the shoulder for ease of movement.

■ The other hand is raised in defensive mode, and the cloak draped over the arm adds emphasis.

three-quarter, front | **back**

On guard

■ Standing ready with broadsword, the weight is on the right leg and the left arm acts as counterbalance.

■ The cloak is pushed over the right shoulder to give the sword arm extra movement.

side, right

■ Due to the weight on the heels and tension on the shoulders, the cape hangs in a very stylized manner, showing just how heavy the material is.

three-quarter, front

■ From this angle the viewer gets a good view of the facial expression. The splaying of the fingers of the left hand creates mood.

side

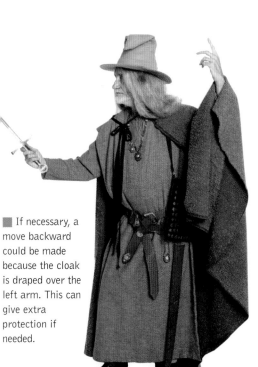

■ If necessary, a move backward could be made because the cloak is draped over the left arm. This can give extra protection if needed.

front

■ The sword could be used for either cut, thrust, or parry, and the position shows that the wizard has used one on previous occasions. The free hand can be used to cast defensive spells.

Making faces

Wizards should have a "fatherly" feel. They are capable of being both stern and kind and have a distinct caring aspect about them.

Wise and solemn

Here the wizard looks pensive and thoughtful, ready to offer help and advice.

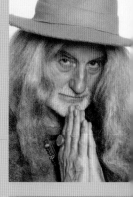

A sudden shock

The wide eyes and open mouth show shock and anger. The shoulder coming slightly forward suggests action is to be taken.

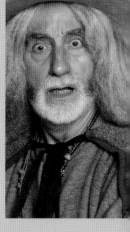

The human touch

Even with his powers and magic, the wizard is still human. He feels all the normal emotions. Here he is laughing, with a sense of innate humanity that makes him a more attractive and warm personality.

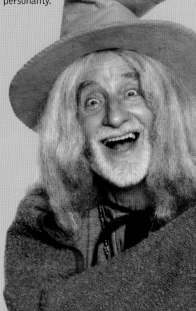

Classic poses

I invoke thee

The staff is an important part of a wizard's equipment. It has many uses, both practical and magical.

■ The wooden staff can be used to cast spells, defend, or as a support when walking.

Bring forth tidings

Here the wizard uses the cloak to invoke status. The pose has authority.

■ Capes and cloaks are a great way for the artist to add motion to a static pose. Striking light and shadow effects add to this.

Pausing to ponder

Although resting on the staff, the upper body is straining forward, giving a feeling of perseverance.

The runes are cast

The billowing cloak adds drama and movement to the stance.

■ The sword belt is worn on the hips, allowing the sword to fall forward and not become entangled in the cloak.

Lay down your arms
Due to the position of the head
and shoulders and the open-
handed way the sword is
being held, this pose has a
feeling of sadness about it.

Greetings
The relaxed pose
and upraised
hand convey
honesty and
diplomacy.

I have arrived
Leaning back slightly,
with a firm grip on
the staff, the wizard
has an aloof
expression that gives
him dignity.

■ The hand
placed on the
thigh is a
counterweight,
allowing the
upper body
and arms to
make more
forceful
movements.

Heed my words
The wizard's position and
the expression on his face
tell us that something
urgent and important
needs to be said.

Vital statistics

Height:
5 ft 11 in. (1.8 m)

Chest:
42 in. (107 cm)

Waist:
34 in. (86 cm)

Shoe size:
10½ (10/46)

Evil Sorcerer

Depicting this particular character, an all-out villain with no redeeming features, gives the artist the opportunity to portray extreme expressions—anger, hate, irritation—and to create dramatic and powerful poses. In depicting the sorcerer the sense of evil can be accentuated in both pose and expression, and can never be too histrionic.

The model is younger than the good wizard (see page 72) and is athletic in his build and posture.

■ The crooked and angular fingers add drama and an element of the weird.

Anatomical studies

Your starting point

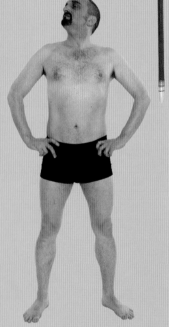

Conceited arrogance

This pose sums up the essentially vain and supercilious nature of this particular individual. The angle of the head, the puffed-out chest, and the hands resting on the hips all emphasize the innate egotism and conceit that is the driving force behind the sorcerer's personality. His stance informs us that he is quite active and has a certain amount of physical strength, which he could use if need be.

■ The amount of stress and tension visible in the body can be an indication of emotion, and the droop of a shoulder or the position of an arm can imply joy or sadness.

Your will is my will

Using the powers at his command, the sorcerer hypnotizes an unwilling victim to obey his orders. The angle of the upper body is forward, and the slight tilt of the shoulders creates a sightline that leads from the eyes to the fingers of the raised hand.

Triumph!

This is a very dynamic, "full-on" pose, with leg and hip thrust forward and body arched back fully. The stomach muscles are tensed, the head is thrown back, and the raised arm follows and complements the front leg. This stance is indicative of the elation of success, with a suggestion of suppressed energy.

◼ The hard stare and raised shoulders, combined with the purposeful forward stride, suggest a feeling of determination and threat.

Forward, chaos hordes

This pose can be considered the evil version of the good wizard's Invoking the Spirits posture (see page 73). Whereas the good will call for protection, the evil will call for destruction. With his angry scowl and advancing posture, the evil sorcerer gestures with arms outstretched to order forward demons and monsters he has called into the realms of men.

From the front and the side

Obey me

This pose has the sorcerer conjuring up supernatural aid. There is a commanding expression on his face, and the way his body is drawn back, combined with the dramatic positioning of his hands and fingers, suggests that there is both physical and mental effort involved.

◼ Although the head is lowered, the raised eyes draw attention to the face, and the raised hands and crooked fingers add further emphasis.

Fleeing to safety

Realizing that he's been vanquished, the sorcerer makes his escape. His backward, furtive glance and lowered shoulders give a feeling of abject defeat, while his hand, raised in a defensive gesture, makes it clear that, although overpowered this time, he will return.

My wrath compels me

This is a very useful pose for character reference. It is a classic "kneeling at the altar" attitude, used for invoking evil spirits or swearing revenge. The position of the legs allows the arms to be drawn out from the side.

From the front and the side

Reach into the flames

The sorcerer reaches toward a mystical object, his attention focused solely on the item before him. The angle of his legs allows him to undertake this extreme pose while maintaining his balance, and his back arm acts as a counterweight to help steady the body.

◼ A pose like this, although difficult to hold for any length of time, is very useful for the artist as an aid to creating striking artwork.

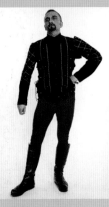

Clothing the figure

Underdress
Everything the sorcerer wears enhances his already sinister aspect. He prefers dark colors, black and red, with patterns and brocades.

Basic dress
The sorcerer wears a black leather jerkin with laced sleeves and silver braid and stud decoration. His soft tooled leather boots have thick soles to make him appear taller.

Decoration
Around his waist he wears a sash, held in place by a snakeskin belt.

Headwear
Over a hood he wears a lacquered skullcap with a scorpion design on the front. Without the distraction of long hair or a hat brim, greater emphasis is given to his face, particularly his eyes.

Amulets and ring
Like his good counterpart, the evil sorcerer has amulets for protection and a ring of power to create spells of attack or defense.

Top layer
Finally, the sorcerer wears a long, heavy, brocade sleeveless overrobe. It's obvious from the fine workmanship that he is interested in wealth as well as power. His ornate costume shows that he wishes to impress and create fear and reverence.

side

Summon the dark lords

▮ The sorcerer uses his staff of power to discharge magic and call up evil beings from the dark dimensions. The way the staff is raised above his head, and the firm grip he has on it, indicates the amount of power it is capable of.

▮ The wide-apart legs and slightly bent knees show that he must use all his strength and concentration to control the energy created.

three-quarter, back

▮ This angle gives a very good view of the heavy sleeveless overrobe and shows how it hangs around the sorcerer.

▮ The overrobe gives the pose a feeling of solidity due to the nature of the heavy material from which it is made.

three-quarter, front

Go forth and destroy

▮ Here the sorcerer uses all his skills in necromancy and the dark arts to dispatch beings of evil intent, to create death and destruction. This pose is one of power and determination.

▮ The outstretched arm and wide-open fingers give the impression that something has been thrown forward, and the upward gaze strengthens the gesture.

front

▮ This angle shows the amount of strain being put into realizing the pose.

▮ The tension is mainly in the upper body, as can be seen by the pushed-out chest and curve of the back.

three-quarter, front

▨ From this angle the amount of concentration the sorcerer needs to cast his spell can be seen. His eyes are fixed firmly on the end of his staff, which he can thrust forward to increase the power and to control the evil he has brought into existence.

front

▨ Viewed from the front, the tension in the stance is apparent. The foreshortening adds to the intensity of the pose, and the attention is drawn to the face and eyes.

three-quarter, back

▨ The back arm, bent at the elbow and wrist, draws the eyeline to the face and then up to the hand and fingers. This produces a sense of the dynamic and a feeling of arrested movement.

side

▨ Here you can see how the material of the clothing moves and falls. The overrobe gives the sorcerer a bulk and breaks up the darker colors.

▨ The whole aspect of this character is hard and angular in comparison to the good wizard. This makes him less attractive in terms of warmth and humanity, but much more interesting to depict as an exercise in villainy.

Making faces

The negative aspects of evil characters should be apparent in their facial expressions. With his trimmed goatee beard, heavy eyebrows, and darkened eyes, we can immediately tell that this person is an utter villain.

Calculating and devious

The evil sorcerer is constantly weighing up his actions and looking for situations that will further his malevolent plans. The quizzical sideways look and the chin resting in the hand accentuate this facet of his persona.

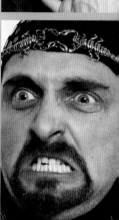

Seething with hate

With villains, extreme expressions can be very effective. The rage shown here indicates a person motivated by wickedness and malice.

Comeuppance?

Eventually good will triumph and evil will be vanquished. Here the evil sorcerer is screaming in terror, as he is about to get his just desserts. The wide staring eyes and fully open mouth evoke fright. This character should inspire fear, but not pity.

Classic poses

You dare threaten me!
This pose shows the sorcerer in all his haughtiness and conceit, his head thrown back with malicious laughter. With arms folded across his chest and feet set wide apart, he feels confident and secure in the knowledge that his magic can deal with any menace.

◼ The pointing finger helps to stress the general feel of someone on the point of departure—but not without a parting comment.

I take my leave
The sorcerer, having made one last warning, prepares to leave. The twisting body and swirling overrobe give a sense of upward movement. The head is turned in the opposite direction to the body's movement, making it obvious that he wishes to make his feelings known.

Watch and wait
Biding his time until the moment comes to strike, the sorcerer's eyes remain wary and alert. He leans on his staff, ready to spring into action. This pose reveals some of the patience and cunning needed to further the aims of the chaos lord.

Demon revenge

Here a spell has gone wrong and the sorcerer is about to be attacked by the very forces he has invoked, and he cowers in terror. There is fear in the facial expression and the hand is raised in a gesture that could either be defensive or pleading. The body is arched back and the weight is being taken on the raised upper leg.

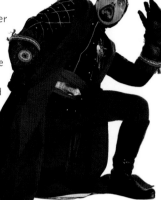

■ The folds and creases in the cape seem to root him to the spot.

Speak to me

The sorcerer holds the skull of a long-dead wizard, hoping to get information from the realm of the dead. Although his stance is casual, the look on his face and the gesture of his hand evoke a feeling of intensity.

■ His attention is fixed firmly on the target, and the grimace on his face shows his intent to kill.

■ The wide-open arms show that he feels safe and secure—there is nothing and nobody to worry him.

■ The legs are wide apart to give stability, and the momentum will come from the arm and shoulder, with the waist acting as a pivot.

Poisoned blade

This character, although in good physical condition, is not that experienced in hand-to-hand combat or the use of edged weapons. He prefers others to do the fighting for him, and will only use a sword or dagger if there is no alternative. The way the dagger is held is not practical for close combat, being used simply to stab, although it may also be used to perform acts of sacrifice to the dark lords.

Revenge is sweet

His wicked plans have come to fruition and the sorcerer laughs with fiendish glee. His upper torso and chest swell with pride and malicious joy. His arms are thrown back in a gesture of victory, and the whole pose radiates malice. The dynamic is maintained by the thrown-back head and slight twist to the body.

84

Warrior Dwarf

Vital statistics

Height:
4 ft 2 in. (1.27 m)

Chest:
38 in. (96 cm)

Waist:
31 in. (79 cm)

Shoe size:
4½ (4/37)

Dwarves are brave, loyal, and trustworthy allies. Although normally half the size of humans, their strength is that of a grown man, and though the proportions are different, the muscle density and mass are much the same as those of a fully grown person.

Dwarves usually live for over one hundred years. The dwarf warrior shown here is still quite young, but very well developed and athletic. Because of his relative youth his beard still isn't fully grown.

Your starting point

Anatomical studies

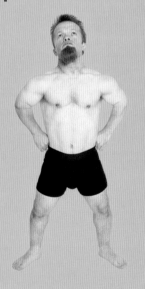

Strong upper torso

Someone is looking down on the dwarf warrior. The hands on the hips and legs planted wide apart show that he isn't frightened and won't be backing down. This should be a recurring theme throughout the depiction of this character.

Onward

The upper body is turned sideways and the arms are swung out to give greater emphasis to the purposeful strides he is taking.

Come over here and say that

The dwarf has a resolute and fearless look on his face, with his arm raised and hand clenched into a fist. This is a character that will stand his ground.

From the front and the side

That pleases me
This casual pose, with the head cocked to one side, shows the strength in his arms and shoulders and the friendly and open expression on his face.

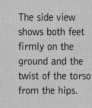

The side view shows both feet firmly on the ground and the twist of the torso from the hips.

Aaarrghhhh!
Venting his rage and frustration with hands pressing down on the head, the warrior's whole body is tense.

Fates find us safely
Arms fully out, hands open. Imploring expression and bent-back head. The dwarf is beseeching the help of his gods.

Take that!
Throwing a punch with a rapid twist of the body, the center of gravity is on the bent leg, giving momentum to the blow. The other arm is bent back, with the fist protecting the face.

■ The straight leg acts as a lever for the rest of the body.

No, you listen to me
Note the determined look on the face. The pose is given added drama by the thrust of the pointing finger and the confident placing of the other hand.

From the front and the side

Running into battle
Running at full speed means the body is lead by the head and shoulders. The torso is pushed forward and the arms are used as counterbalance. The head remains upright for better vision and to maintain direction. The pressure on the legs and the speed attained are measured by the bend of the knee.

■ The firm stance of the legs adds to the drama of the pose.

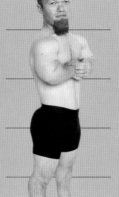

Clothing the figure

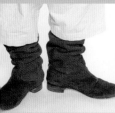

Shirt and surcoat

A linen shirt and heavy quilted surcoat allow for movement while giving protection.

Footwear and breeches

Leather knee boots "drop" and crease around the ankles. This makes them more comfortable to wear for long periods. The dwarf also wears heavy linen breeches.

Belt and pouch

Note how the long belt is looped back through itself and pulled tight.

Armor

The scale mail tunic is called a "hauberk," and the metal lower arm guards are known as "vambraces."

Cape

The heavy wool cape has an embroidered edge and is pinned at the shoulder with a metal clasp.

three-quarter, right	back

Listening carefully

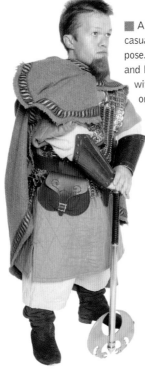

■ A fine example of a casual yet interesting pose. The dwarf is looking and listening attentively, with both hands resting on the ax. Relaxed but attentive.

■ The rear view shows the drape and fall of the cape.

front	three-quarter, left

Ax attack

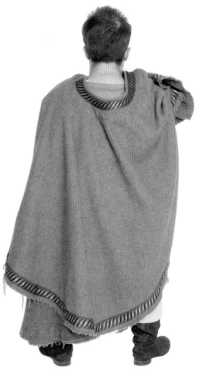

■ Wearing a nasal-bar helmet for added protection, the dwarf is bringing down his battle-ax. Both hands firmly grip the handle.

■ The upper body is turned to create momentum with the swing of the weapon. The weight is placed on the forward leg, and a stern expression confirms his intent.

three-quarter, left

▓ The sleeves are tucked into the arm guards and the ax rests in such a way that it can be brought up for use quickly.

front

▓ The front view shows the face and the positioning of the hands and armor. This pose and expression give a sensation of rugged dependability.

back

▓ The back view shows how the movement of the cape relates to the movement of the wearer.

three-quarter, right

▓ The flexible scale mail turns and moves with the wearer. The feet need to be flat to act as a break on the movement of the ax.

Making faces

Dwarves are open and robust and express their emotions easily. They can be just as quick to anger as laughter.

Think it over

This expression indicates the diligent and prudent aspect of the character. He listens carefully before expressing his opinion. The slight frown and turn of the head accentuate this.

Flash of anger

The downward tilt of the head, with the eyes looking up from beneath the brows, shows that the dwarf is about to explode in anger.

A nasty surprise

Here we see shock and surprise, with the open mouth, wide eyes, and head slightly forward.

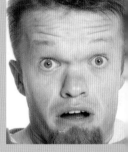

Battle cry

Before going into battle, the warrior dwarves call on their gods to give them protection and courage. They also chant the names of their ancestors and the deeds of valor for which they became famous. The hands raised to the face and the mouth open wide stress the physical power put into the cry.

Classic poses

Tiring work

It's hot under armor, and here he has removed his helmet to wipe his brow.

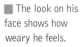 The look on his face shows how weary he feels.

Prepare to meet your maker!

Here there is an exaggerated arc to the upper body as the weight of the ax pulls the dwarf back.

■ The center of balance is on the left leg, while the right one acts as a pivot as the ax is brought down to the right in a full swing.

Into the fray

Arms thrown out wide, legs apart, this pose shows that he is excited and overjoyed to be finally facing his enemies on the field of battle.

Victory

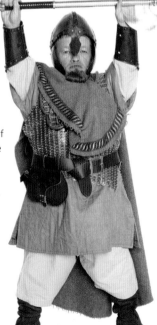

The exultant look on the face, with more than a hint of arrogance, and the ax raised over the head show clearly that the battle has been won and our hero has fought well.

Resting

Sitting down, listening to the conversation, the dwarf rests his hand on the ax. He might have to use it suddenly, which is why it cannot lay flat on the ground.

Call to arms

A surprise attack means that there was no time to put on his helmet. He calls forth his companions to come and support him.

■ Note the difference in the depth of creasing of the clothes, depending on the weight of the material.

Walking in the rain

Walking forward into the storm, the warrior's body is bent into the wind. He has removed his helmet and drawn the cape over his head to give some protection. He is being stoic about getting drenched. It's always worth remembering that a warrior is not always fighting on the field of battle, and that it can be far more interesting to depict characters in nonaggressive poses.

Vital statistics

Height:
5 ft 8 in. (1.73 m)

Chest:
42 in. (107 cm)

Waist:
40 in. (102 cm)

Shoe size:
8½ (8/40)

Cleric

The cleric can function as a comedic character, usually shown as big and jolly. A lover of food and comfort, he dislikes hard work and roughing it.

Although on the surface the cleric appears jovial and easygoing, he can be a faithful comrade and a useful ally in a fight. He also possesses an innate sense of right and wrong, and will strive to fight injustice with an energy and intuitive wisdom that belies his appearance.

The cleric character can be used in lighthearted scenarios as well as dramatic ones, and he can make a worthwhile addition to any fantasy scene.

Your starting point

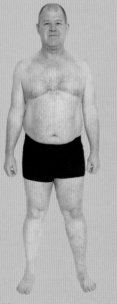

Anatomical studies

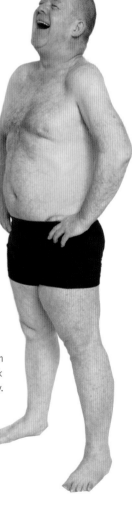

A fine jest
Greatly amused and giving a hearty laugh, the hands on hips and head thrown back show that the cleric's body is shaking with laughter. His mouth is open wide and his eyes are slightly screwed up with effort.

■ His legs seem shorter in proportion due to the bulk and size of his upper body.

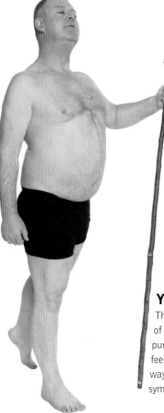

Size matters
The model is stocky with a large stomach and a soft fleshy look. His muscle tone isn't well defined and the whole body is rounded in appearance. In spite of his size, the cleric is capable of extreme physical effort, although it cannot be sustained for long periods.

You may journey with me
The haughty look on the face and tilt of the head, combined with a casual yet purposeful stride, give this pose a feeling of pomposity, particularly in the way the staff is held forward like a symbol of office.

From the front and the side

Oh no! Goblins!

This reaction pose features elements of drama and comedy. The extreme expression on the cleric's face, the position of his hands, with splayed open fingers, and the bent knees, create a feeling of fear and panic.

I'll teach you some manners

Holding the quarterstaff ready to administer a sound beating to an adversary, the resolute look on the cleric's face informs us that he means business.

▉ The tension in the arm muscles shows that in this stance the attack can come from above or below, while the position of the legs means that rapid forward or backward movement can be made with ease.

Deep in thought

The contemplative nature of this pose is made apparent by the hunched shoulders and the way the cleric's face rests on the staff.

▉ Although his head is lowered, the fact that his eyes are looking upward tells us that he is attentive to others and their needs.

▉ His wide grin and pulled-in chin tell us that he is looking forward to his dinner.

Let me through!

Here the cleric is running away from danger. His back leg is high in the air and his head is turned in the direction of whatever it is that is pursuing him.

▉ His arms, held out in front, push past obstacles for a clear path.

Mmmmm, pies!

Standing with smug anticipation, the cleric rests his hands contentedly on his chest.

No, that is not the way to do it

The cleric's finger, raised in admonition, and his stern expression give this pose obvious status and power. The fact that his sightline is downward also tells us that whomever he is addressing is either small—such as a dwarf or child—or seated. The cleric is using his position to impose authority.

Clothing the figure

Undergarments and footwear

Simple drawstring breeches are worn with leather, closed-toed sandals that have flat soles and no left or right shape.

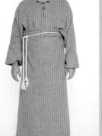

Underrobe

The heavy gray/beige woolen shift underrobe is made shorter by pulling the excess over a rope belt, tied with a single knot at the side.

Hood and tabard

The underrobe has a separate matching hood. The square-cut simple tabard is made from a darker, less heavy wool, and is also held in place by the rope belt. Only the front of the tabard is held in place. The back is allowed to hang loose, to prevent it tugging back and putting pressure on the cleric's neck when he sits or kneels.

Short sword and belt

Due to his "spiritual" nature, the cleric prefers fairly unobtrusive weaponry, worn on the right. The sword is used more like a knife, to chop firewood, slice food, etc., but he can and will use it in a fight if he has to.

Wardrobe

Clerics wear heavy, rough woolen robes in several layers. Colors are dark, such as grays, browns, or black. If white is worn, it should be a slightly yellow shade, almost cream. The clothing is simple and practical. It is warm, hard-wearing, and loose-fitting. The various textures of each item need to be accentuated to show the different weaves and weights.

front	three-quarter, front

I'll travel with you, but . . .

■ The pomposity of this pose lies in the way the cleric is standing, with his bulk pushed out to intimidate.

■ The expression is disdainful and wary. He is weighing up the options before making a final decision.

three-quarter, front	front

I don't just use this to slice bread

■ This stance shows that the cleric knows how to use an edged weapon.

■ His body is tensed, ready for attack or defense, and his gaze is concentrated on his opponent. The purposeful expression shows his determination to win the combat.

side, left

The out-thrust stomach makes him appear larger. The position of the legs, wide apart with feet firm on the ground, adds resolve.

side, right

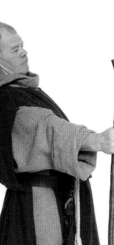

He holds the quarterstaff out in front to clear a wide area around him, making his size and bulk even more imposing and giving him space to use the staff as a weapon.

side, right

side, left

The other arm acts as a counterbalance to the sword arm. Its movement can also be used to distract and confuse an enemy. The positioning of the feet gives extra balance and increased stability.

The short sword is held so that it can be used to slash or thrust, or to parry and block a counterattack.

Making faces

The cleric is a great subject for showing a full range of emotions and expressions.

Let's talk

This friendly and open expression encourages others to confide in him.

Righteous anger

The downward tilt of the head, deep frown, and slight sneer on the lips warn that he is about to seriously lose his temper, and those responsible will regret it.

Riotous laughter

A happy, laughing face. The cleric's eyes are closed with effort and sheer joy, and his shoulders are obviously moving up and down as he rocks with laughter.

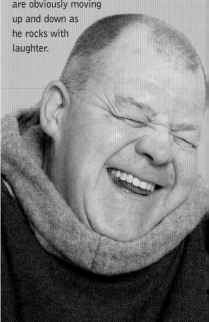

Classic poses

What a dilemma!

A contemplative cleric, pensive and deep in thought. The chin-rubbing gesture and serious look on his face tell us that it is a very serious matter that concerns him. The slightly stooped posture creates the feeling that the thought has occurred to him suddenly, in midaction, causing him to pause. The hood worn up adds to this impression.

Please help?

Down on his knees, the cleric prays for aid. Looking up to the heavens, his expression is both submissive and scheming. He would like the help, but not if there's too much effort involved on his side. This pose shows one of the other aspects of the cleric's character, that he can have a duplicitous and conniving nature where hard work is concerned.

■ The tabard is moved back from the upper leg and the robe is pulled up to prevent gathering up when kneeling.

More ale!

Sprawled back and relaxed, the arm raised with tankard asks for a refill. Here the cleric is jovial and contented. He has spread out his overrobe to make it more comfortable to lie down.

■ The weight of the body is taken on the elbow and the bent bottom leg, allowing him to raise the opposite shoulder and arm without having to sit too far up.

■ He is using his quarterstaff like a shield, to protect him from counterblows and keep his attackers at bay, and the expression on his face accentuates the drama of the pose.

Have at you!

The cleric is charging forward into the fray. The speed and extent of his movement can be seen by the way the underrobe is tight against his legs, with few creases. This shows how wide apart his legs are. Both hands hold weapons, and the arms are thrust forward from the body.

A toast to you all

In this cheerful and lighthearted pose, the cleric's tankard is raised to his mouth as he takes a large gulp of ale. It appears that he has only just started to drink, because his head is not tilted too far back. His raised eyebrows show his enjoyment, and the body posture is very relaxed.

■ The pushed-out stomach is emphasized by the other hand, resting on the hip.

■ The top layers of his costume bunch together and act like a blanket as he sleeps.

Just resting my eyes

Fast asleep after a long day's eating and drinking, the cleric recovers from his efforts. He is sitting comfortably, head lolling to one side, with puffed-out cheeks that make it obvious he is snoring. The hands, with linked fingers, resting on the stomach give a feeling of peaceful relaxation.

■ The feet are placed wide apart, allowing the head and upper body to bend back to increase the speed of the flow of his ale.

■ The cleric's hands are resting, hidden inside his sleeves, which is a stereotypical pose for this character.

■ The cleric's eyes are fixed on the path ahead, and there is an element of trepidation on his face.

The journey begins

Here the cleric is wearing a heavy, hooded traveling robe. The difference between a cape or cloak and a robe is that robes are either sleeved or have gaps for the arms to go through, similar to a coat. Capes do not have these, being drawn across the body or pushed back over the shoulders.

That's a lot of stairs!

From the look of shock on his face, and the raised eyeline, we can see that the cleric is about to undertake some sustained physical activity. The way he is standing suggests that he has come to a sudden halt and slowly raised his head, while the position of his mouth implies a sharp intake of breath.

■ He has taken a deep breath in and puffed up his already considerable bulk to appear bigger and stronger.

■ The long robe reaches down to the ground and gives plenty of protection and warmth.

Steadfast and staunch

The cleric has a firm and resolute look on his face. This could mean he's hoping to face down his opponent without having to actually draw his sword; sometimes the threat is enough.

■ The feet are placed wide apart emphasizing his bulk.

■ His sideways stance confirms that he knows how to use a weapon.

I'm a man of peace, but . . .

Crouched ready for a fight, the cleric's expression tells his opponent to use caution and be on guard. His body is turned slightly sideways to present less of a target, and his feet are turned out relative to his shoulders. Although his robe and tabard are made from heavy wool, the loose fit allows for easy movement.

Last licks

Here we clearly see the greedy aspect of the character, as he determinedly scrapes out the last of the gruel and licks his fingers. Giving characters an element of comedy and picking up on their faults and flaws makes them more interesting individuals to depict, and makes their selfless and heroic actions are more impressive.

▓ With head thrown back, the cleric's laughing mouth and raised cheeks cause his eyes to close, and his raised shoulders push out his double chin.

▓ The furtive look on his face and the bowl held close to his chest hint that he is attempting to keep his conduct secret, and doesn't want to share.

Now, that's a good one!

Rocking with merriment and holding his aching stomach, the cleric is the very image of unbridled joy and happiness.

▓ He has removed his sword, which means he is in a safe environment, at an inn or beside a campfire for example, and because he feels secure, his enjoyment and laughter is much more intense.

Vital statistics
Height:
5 ft 10 in. (1.78 m)

Chest:
42 in. (107 cm)

Waist:
34 in. (86 cm)

Shoe size:
9½ (9/44)

Peasant Boy

The young peasant boy is a fun character to depict. He can be either brave or cowardly, overconfident or shy. His physique is slender but athletic, he is constantly on the move, and he has a furtive air about him. While he has the possibility of being heroic, more often than not the peasant boy is a lovable rogue. The artist's depiction of the peasant boy should play on these character traits, and any prominence given to them will strengthen the final result.

The model used here is in his mid-twenties and has a rough-and-ready look.

Your starting point

Anatomical studies

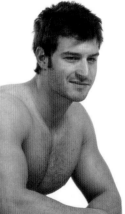

A funny tale
With head thrown back, shoulders out, and hands on hips, there is a relaxed, happy feel to this pose.

A confident stance
There is more than a touch of confidence about this character. His build is slender and athletic, and he uses it to his advantage.

At the campfire
Another relaxed pose, although the feet raised on the toes and the pensive look on the face suggest that the boy might leap into action at any moment.

From the front and the side

Run for it!

This is a great action pose, with the body thrust forward and the weight on the front leg. The left hand is clenched into a fist, adding to the arrested movement suggested in the pose.

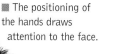

■ The positioning of the hands draws attention to the face.

That's fighting talk

Fists raised, the boy is ready to throw a punch. Emphasis should be on the hands and shoulders.

■ A stern expression shows his determination.

How do I get out of this?

Deep in thought and oblivious to everything, the boy's whole body is drawn in, and his shoulders and neck are tense. The balance of the body is taken down through the chin to the hand holding the elbow, then to the hips.

I'll be back

This is a useful arrested motion pose. Turning in midstride to wave farewell, giving the body two areas of separate momentum, the legs move forward and the torso pivots at the waist, suggesting movement.

■ The feet are firmly planted on the ground.

Got it!

The weight of the body is being taken on the upper thigh, using the lower leg as a brace. This allows the boy to bend further forward without losing balance. His sightline follows the direction of his outstretched arm, stressing the look of concentration.

■ The other hand is in a position for grabbing.

Clothing the figure

Shirt
The shirt is loose and made of linen.

Legs
In real life, tights, like the heavy cotton ones worn here, always bag at the crotch, however the artist may wish to make them more smooth and sheer in the artwork.

Footwear
Soft suede ankle boots, with leather soles and laces, are oiled to keep them supple and waterproof.

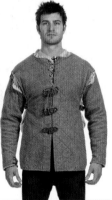

Jacket
Woollen jerkin with separate laced sleeves for ease of movement. The shirt is pulled through the lacing for decoration, and the sleeves can be removed and the jerkin worn like a waistcoat.

Cape
The rough, hooded traveling cape should not be too heavy, and is left raw-edged. It has a broken-down and dirty look, and can also be used as camouflage.

Wardrobe
Peasants wear rough, hard-working clothes, their dress reflecting the type of manual work they are expected to do. Go for heavy wools and linens in dark, earthy colors.

three-quarter, front	back

Pin it to the wall

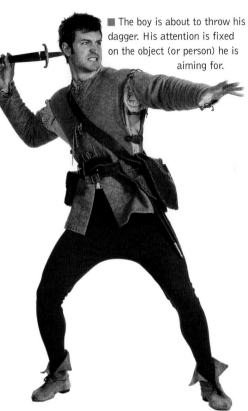

▪ The boy is about to throw his dagger. His attention is fixed on the object (or person) he is aiming for.

▪ The dagger is held by the blade, avoiding the sharp edges. The pommel acts as a counterbalance to help with the aim.

three-quarter, front	side, right

Come on then!

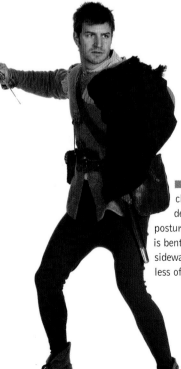

▪ This is a classic defensive posture. The body is bent and turned sideways to present less of a target.

▪ The dagger is being held in such a way that it can be used to thrust or parry.

side, left

▨ The left leg will take the strain when the knife is thrown.

front

▨ The whole body—which is tense all over—acts as a fulcrum to maintain equilibrium. Particular attention should be paid to the hands and eyes.

back

▨ The legs are bent coequally to enable rapid movement, either forward or backward. Both feet are firmly on the ground.

side, left

▨ The cape is rolled around the left arm and can be used as a shield or flicked at an opponent's face to create hesitation or confusion. Therefore, the positioning of the cape should be relative to the opponent.

Making faces

The peasant boy should have a bold and likable personality. If he is a villain, he should be a minor and redeemable one. His facial expressions will show these character traits.

Trust me

The lopsided smirk and half-closed eyes show that the peasant boy has hidden motives and his own agenda.

Who, me?

Trying hard to look innocent, the barely suppressed smile and raised eyes suggest that, in spite of his fine words, he is an insincere fellow.

Maybe, maybe not

The serious mouth and raised eyebrow tell us that he is carefully pondering his options and chances of success.

Take that back!

With a wild yell, the peasant boy lunges into the fray. The more extreme the facial expression, the greater the visual impact.

Classic poses

Caught in a brawl

The boy is in a fighting pose, and is using the dagger in both hands for greater effect. The attack has happened suddenly, otherwise he would have had time to remove his cape for freedom of movement.

■ The muscles of the legs strain with the tension of the pose.

What was that?

Crouched down, with knees bent forward and hands used for support, this pose shows a combination of fear and alertness. The boy is straining to hear further sounds before he can decide on what action to take.

■ The cape is drawn over his shoulders, and the hood is pulled up to make him less conspicuous.

Hey, I can explain

The wilfully innocent expression, wide-open arms, raised shoulders, and gesturing hands show that the boy is trying to talk his way out of an awkward situation. Overdone responses and reactions indicate underlying deception, since a person can protest too much.

■ The hands are wide open in an attempt to convey innocence.

I had it when we left

Casual poses are every bit as important as action ones. This pose shows how the cape hangs as the body turns, and how the traveling pouch is used—one hand holds open the flap, keeping the pouch close to the body.

Counting the cash

Enjoying the result of a night's work, the peasant boy gloats over his ill-gotten gains. He is wearing his cape around him, so he is probably outdoors and well hidden.

Time to move on

The boy has just woken up, so he is yawning and stretching his upper torso. The cape has been used as a blanket and is worn on the collar line.

Missed me

Down on all fours, the body is raised slightly with hands flat and elbows bent, ready to leap up and run.

▦ Note how the cape folds around the body and how the shoulder strap hangs down.

Vital statistics

Height:
5 ft 3 in. (1.6 m)

Dress size:
10 (12/38)

Shoe size:
8 (6/39.5)

Peasant Girl

The peasant girl is aged between 18 and 23. She is kind, loyal, and generous, but she is nobody's fool and can see through tricksters and frauds. Physically she is quite buxom, with a pretty open face and a healthy outdoor complexion. She is no stranger to hard work and has many skills in the home and field.

The peasant girl can be brave and play the heroine, looking for adventure, or she can be demure and mistress of hearth and home. She may be in need of rescue, or be the rescuer, and she can fight if the need arises. These contradictions can make her an interesting and fun personality for the artist to depict.

Your starting point

Anatomical studies

■ The curve of the back allows the arm to be lowered without bending it.

Take that path
Here the body is turned on the hips, which makes the gesture more emphatic. The sightline follows the positioning of the hand, while the other hand is upwardly angled relative to the twist of the torso.

Gentle curves
The peasant girl has a gently rounded physique. Although she doesn't show obvious muscles, she is strong and healthy. Here she is walking away from someone, but the flirty look on her face suggests that she hopes that person will follow her!

A precious object
This is a kneeling pose used for picking flowers or picking up objects.

 She is looking intently, and her smile tells us that this object is special.

Look!
A useful "holding" pose and a casual position. Her right arm is raised, and the bend of the elbow indicates the weight of the object resting in the palm of her hand.

From the front and the side

Picking rosebuds
This is a very useful pose that can be used as reference for various scenarios, such as picking flowers or holding objects.

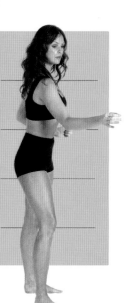

Distribution of the weight is equally balanced on both legs, with a slight turn of the body.

■ The outstretched arm acts as a counterbalance to help maintain the posture.

■ The shocked expression and raised arm show that the character is powerless to prevent something horrible happening.

Midnight abduction
From the positioning of the body in this pose, it is obvious that the peasant girl has been suddenly woken. A lying pose can often create a feeling of helplessness, particularly if the character is cowering away from something.

Yes, new shoes
A dainty pose with foot raised. The girl is looking down, with her shoulders turned sideways.

Shall I keep it?
This kneeling pose suggests a relaxed feeling; she doesn't have to stand up quickly and her attention is fixed on the object that she is holding.

From the front and the side

Stay back!
In this very dramatic stance, the peasant girl fights off an attacker. The aggression contained in the pose creates a very angular figure—all elbows and knees. The way she bends back from the waist and the positioning of her legs show the amount of effort she will put into defending herself from harm.

Clothing the figure

Undergarments
A cotton chemise and long petticoat are worn as two separate items.

Footwear
Simple open-toed sandals with leg lacing are suitable for town streets and rough and wet terrain.

Skirt
A heavy, cotton pleated skirt with fine embroidery sits slightly higher than the petticoat. This means that mud splashes only get as far as the petticoat, which is easier to clean than the skirt.

Bodice
The bodice is laced up tightly at the waist but looser at the bust.

Cape
A full-length hooded cape is worn for warmth and protection from the wind and rain.

Practical and proud
Although simple and hardwearing, the overall look is very attractive. The peasant girl takes a pride in her appearance and enjoys turning the local boys' heads.

side	front

That is the road to travel

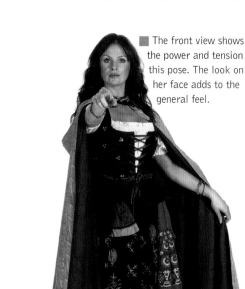

■ The girl is pointing the way for the rest of the group. The drama is in her gesture and stance.

■ The front view shows the power and tension in this pose. The look on her face adds to the general feel.

side	front

Stay away

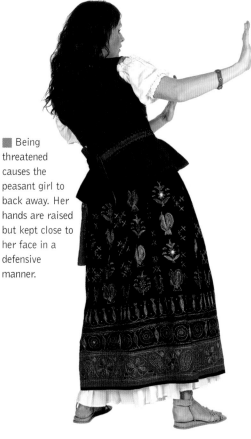

■ Being threatened causes the peasant girl to back away. Her hands are raised but kept close to her face in a defensive manner.

■ Although nervous, her feet remain forward and her upper body curves away, showing that she is not frightened enough to run.

back

■ The hooded cape has an extra lining that causes deep pleating and folds in the way it hangs.

three-quarter, front

■ The heavy cape pulls back on the shoulders and is held away from the body.

three-quarter, front

■ The look on her face is indignant. The hands could be used to defend or to attack.

back

■ Although her costume is not elaborate, interesting details can be found in the red sash and the hidden dagger.

Making faces

The peasant girl has a pretty face with a fresh, healthy complexion. She is attractive rather than glamorous. Growing up on the farm means she knows the way of the world and should in no way be thought of as naïve.

Hidden hopes

The expression here is pensive and quizzical, thoughtful and composed. The small smile also makes her endearing.

Daydreamer

The far away look in her eyes indicates that she has a romantic streak within her.

A happy heart

The peasant girl has an easygoing sense of humor and is quick to laugh and enjoy life to the full.

Classic poses

Lost in thought

Gazing into the distance, the peasant girl's thoughts are far away—thinking of a loved one perhaps.

■ The skirt lies flat around her, acting as a covering for her legs, and she rests her weight on the straight left arm.

Just you try it

This pose shows that the peasant girl can, if need be, fend for herself. The way she stands and holds the dagger hints that she has probably used one before.

■ Her outstretched arm balances the pose.

Stepping stones

This pose shows how the skirt can be raised when walking or climbing. The petticoat underneath is shorter than the skirt and does not get as muddy or dirty on the hem through use.

■ The slight smile suggests that she is not taking it too seriously.

My lords and ladies

A curtsey is performed as an acknowledgment of a person of higher status.

Dance with me

This pose shows how the skirt moves in relation to the bodice. The peasant girl is graceful and light on her feet when she needs to be.

■ The way she holds the corner of her skirt up emphasizes her natural charm and poise.

Into the night

The careful way the peasant girl is walking, with the candle held close to her body, tells us that it is a dark and gloomy night.

■ Her cape is pulled over her shoulders and allowed to drop down, covering up most of her.

Picture of innocence

The peasant girl is trying too hard to look blameless. She is avoiding eye contact with anyone and is whistling a little tune. Actions and expressions such as these are a good way of depicting motivations and reactions.

Hello boys

Using feminine wiles to get her own way, the peasant girl flirts and tries out all her charms. The open smile and wide eyes show that she'll probably succeed in getting her way.

■ With her hand on her hip, the girl plays with her hair, giving her a coy element and making her seem more amenable.

Take me to the fair

The peasant girl waits, ready to be taken on a trip. She is wearing a shawl, so it is obviously a journey outdoors, and her skirt is hitched up to aid walking. Her whole pose and expression is one of anticipation.

■ The way the body is turned, with legs and hips one way and head and body another, indicates she is eager to get going.

What's that?

Her suspicions are confirmed as she eavesdrops on a plot that could place her in danger. The look on her face is one of concerned attention, but she won't let her guard drop, and her eyes scan the area for other threats.

■ She cranes forward to hear better, but is ready to flee at a moment's notice.

■ She holds the cape away from her body for a quick getaway.

■ The angle of the body shows that she is unsteady on her feet.

Almost there
After a long trek, the peasant girl finally comes into sight of home. The whole dynamic of the body is of forward movement. The arm and hand shading the eyes draw her toward her goal.

■ She is carrying her cape now, which indicates that she no longer needs to wear it, however she did take it with her, so she has probably traveled overnight or in bad weather.

■ The folds of the cape follow the contours of her body. The single visible hand holding the cape close draws attention to her face. This creates a sense of apprehension and drama.

Cheers, me dears!
Although she holds a full glass and is obviously enjoying the effect of the wine, it is always problematic depicting inebriation in female characters. It's not a very attractive trait. While a barbarian or Norseman can get roaring drunk, the most a female should get is a little tipsy and playful, rather than aggressive.

Blowing a kiss
A final parting gesture of farewell can be given different connotations—sadness, yearning, relief—depending on the facial expression. The jaunty angle of the peasant girl's hips and shoulders, the hitch of her skirt, and the fall of her blouse give this pose a playful feel.

■ Note how the different layers of clothing sit on the body, and how the bodice emphasizes and flatters the bust and hips.

Against the night
Wrapped up in her cape, the peasant girl waits for the stranger who sent her a message arranging a midnight meeting. The pensive look on her face and the cloak drawn protectively around her with the hood raised say that she is wary about what might happen.

Vital statistics

Height:
6 ft (1.83 m)

Chest:
44 in. (112 cm)

Waist:
38 in. (96 cm)

Shoe size:
10½ (10/46)

Norseman

This tenacious fighter comes from the desolate frozen wastes of Ultima Thule. He is rough and ready, loyal and dependable to his comrades, and the terror of his enemies. His word is his bond, and he has a strong sense of honor and natural justice. In the fantasy world he often takes the heroic role or that of close companion to the hero.

For artists the Norseman can be a very interesting and rewarding character study, in terms of anatomy, costume, and the variety of arms and armor that can be used. The model here is quite stocky, and is obviously suitable in appearance, with his long hair and full beard.

Your starting point

Anatomical studies

By this ax I rule

This pose is ideal when depicting the use of the large battle-ax or double-handed sword. It is important that a clear feel for the actual heft and heaviness is achieved. This should also be shown in the tensing of the muscles, particularly in the arms and legs, to give a real sense of physical combat.

■ The elbows are out and the arm muscles are taut to take the strain.

■ There is not too much bend in the knee, otherwise he might overbalance.

Weight distribution

Endomorphs can be more difficult to depict than mesomorphs, because the distribution of their body weight depends purely on what movement they are undertaking: fat is not attached to the body and can move around when the person is in motion.

How lies the land?

A good casual pose, but still with a vigorous feel to it. The way the Norseman is kneeling is not restful. Instead he is taking a pause to consider his options—which path to take, the number of adversaries to fight. He is still ready for action. He has a pensive and thoughtful look on his face. His elbow rests on his raised knee, with the heel slightly raised to maintain balance, while the other hand on the thigh allows for the pressure he will need to help him stand.

■ He has a confident expression and the position of the arms, folded across the chest, emphasizes the shoulders and arm muscles.

From the front and the side

Have at you, cur

This is a stereotypical stance for the use of edged weapons, such as swords, axes, and so forth. The weapon arm is raised to head level, with the elbow out to increase momentum.

The impetus is on the front leg, because when the weapon arm sweeps down the upper body will twist with the force and weight of the blow. The rear leg acts as a shock absorber when the weapon hits its target.

On my own terms

The Norse warrior stands proud and aloof. He will commit himself only after careful consideration, namely, does the proposal involve fighting, drink, or loot? If it does, along with the possibility of his deeds becoming the stuff of legend, then he will pledge his aid.

Blood of my forefathers

With head thrown back, the Norseman gives a hearty laugh, enjoying the moment. This could signify a triumph against great odds in battle, or the winning of a challenge at drinking. He has an exultant look on his face, with shoulders back and arms full out to give feeling to the action.

Come over here and say that

The Norseman doesn't take insults or name-calling lightly. A slur on his honor won't be ignored. Here he adopts a pose ready to demand an apology, or force his opponent to face the consequences.

■ His fists are clenched, ready to use, and the forward move is led from the shoulders.

You're a dead man

Coming forward, about to attack, with battle cry on his lips, the Norseman plants dread in the hearts of his enemies through his rage and lack of fear. His body is coming toward the opponent, led from the head and neck, and the arms are tucked in to allow for a sudden thrust forward.

I'll wrestle you

Preparing to grab his opponent in a match of physical strength, the Norseman is ready to prove what a formidable adversary he can be, even without weapons. He won't allow anyone to get the better of him. His legs are tensed with feet wide apart, their position enabling shift of weight. The body is bent low at the waist and the arms are held out, ready to grab the antagonist.

■ From this angle the back leg is foreshortened as impetus is maintained.

Clothing the figure

Shift and breeches

The Norseman wears thick woolen tweed or moleskin breeches, and a long, undyed, heavy linen shift with a cord belt.

Wardrobe

The Norseman wears several layers of hard-wearing clothing. The dyes are not colorfast, so his clothes tend to have a slightly faded, washed-out appearance. Colors are mainly pastel shades, with an emphasis on blues and reds.

Footwear

Above the soft leather boots, cloth strip puttees wrapped around the ankles keep the breeches from getting dirty.

Tunic

A long-sleeved woolen tunic or kirtle with embroidered edging is held with a thin leather belt.

Mail

On top of the tunic a metal mail hauberk can be worn, with a hunting knife and leather sheath secured on a belt.

Belts

The two leather belts are worn together, with the excess belt material looped over to secure them.

Cape

For warmth and protection from bad weather, capes are held in place with ornate clasps. Here a poncho-style traveling cape with embroidered edge is pulled back and held in place with a metal pin. Fur waistcoats may also be worn.

| front | three-quarter, front |

Ax attack

■ The Norseman is getting ready to use the long-shafted battle-ax, in a stance suitable for both attack and defense.

■ To increase the power and the swing, and inflict greater damage, the left hand grips the ax at the base.

■ When the weapon is swung, the right hand slides down the shaft to meet the left, increasing momentum and adding to the power of the blow.

| front | side, right |

Close combat

■ This position is used for combat in an enclosed space, or close body fighting. Since he has removed his helmet, this could depict a duel, or trial by combat, rather than duty on the battlefield.

■ The weapon hand is held back ready to thrust or parry. Wide slashing gestures would be avoided.

back

side

■ The Norseman has slung his shield over his shoulder to keep it out of the way. It still gives him a certain amount of protection.

■ The legs need to be placed apart because they will have to bend to compensate for the weight of the ax.

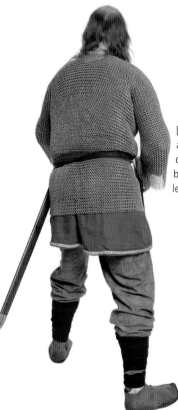

back

side, left

■ The sightline is fixed on the hand, which is used to distract his adversary. He can also make a grab for his opponent's weapon hand.

■ The arms are held in close to the body to present less of a target.

Making faces

With this character it is important that the artist captures the innate pride and dignity of his nature, without losing sight of the rough-and-ready aspects.

Treat me with respect

The haughty expression is reinforced by the fact that he is looking down at the viewer. The slight sneer on the lips enhances the image.

Don't question me

The lips drawn back, showing the teeth, and the lowered brow, plus a direct stare, tell us that he is argumentative, with a short temper.

Battle cry

The helmet dehumanizes the wearer and makes him sinister and imposing. His eyes, although somewhat hidden, draw attention, and the jutting lower jaw informs us that he is in full cry: a frightening image.

Classic poses

Bite of the broadsword

Here the Norseman uses the double-handed broadsword to clear a path of death and destruction. It is a terrible weapon that can easily split a man in two. He has discarded his shield to allow for freer movement.

It's going to be a fine battle

Stoically watching the opposing armies mass, the Norseman weighs up the odds. He wants to make sure he will face all dangers without fear, and if he should die that his deeds will pass into legend. His body weight rests mainly on the sword, and the heavy mail sleeves hang down.

■ The sword has a second grip above the guard to allow him to bring it down with great force.

■ His cape is pushed away from his sword and scabbard.

■ He wears his fur waistcoat for added warmth, and is slightly unsteady on his feet.

A toast to you all

Norsemen are great drinkers and carousers. Holding up his drinking horn, he salutes his comrades as they relax after their efforts.

Give my greetings to the gods

Involved in a brawl, the Norseman uses sword and dagger to deadly effect. His lack of finesse is more than made up for by his rage and strength. The straight arm shows the powerful thrust.

■ With front leg bent to facilitate forward movement, the back leg acts as a brake for pivoting.

In one swallow

Here he proves his ability to hold his drink. With head thrown back he drains the horn in one swig. His body is tilted back, and with one hand he holds the horn steady at his lips, then raises it up.

■ The curved angle of the body suggests drunkenness.

Come back and fight, craven dogs

Yelling defiance and threats, the Norseman has sent his attackers running for their lives. They fear the cutting power of the terrifying ax he uses.

■ Here his whole body is tensed, adding power to the battle cry.

Goblin

Depicting goblins allows artists to create unusual facial details and exaggerated poses.

The goblins are the foot soldiers of the armies of chaos. They are vicious, although they can be cowardly in single combat. Goblins are not human, but twisted travesties, and any depiction should emphasize this aspect.

Goblins can never be too horrific, and the more ugly and evil looking they are, the better the result. With these characters the artist can get some excellent practice at depicting extremes of anatomy. The model shown here is very adept at moving his limbs in such a way as to suggest something more beast than person.

Vital statistics

Height:
6 ft 2 in. (1.88 m)

Chest:
40 in. (102 cm)

Waist:
34 in. (86 cm)

Shoe size:
12½ (12/47)

Your starting point

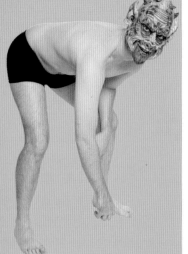

Goblin anatomy
Although exaggeration and distortion can be used to create horrific and monstrous individuals, a good understanding of normal anatomy is required to make any pose convincing.

Anatomical studies

On guard
Here we have what could be termed a casual pose, the suggestion being that goblins are like apes, in that their natural posture is bent at the hips and knees with knuckles on the ground. The impression given is that, although they can stand upright when need be, they prefer to creep and crawl.

It's there I tell you
Here the goblin's arm is pointing straight out, and the outstretched little finger gives the gesture added emphasis. The nature of this pose, that of tracking others, is made obvious by the position of the legs.

■ The right knee is not touching the ground, and the left arm rests on the left knee, enabling the goblin to rise quickly from the squat.

From the front and the side

I'm ready

This is a good aggressive stance, with arms out and muscles tensed. Note how the hands are open wide with the fingers bent to suggest claws. The weight is equidistant from the upper torso to the legs.

■ Movement can be made quickly, either forward or backward, depending on the response. Following the eye level of the goblin reveals that his opponent is taller than him.

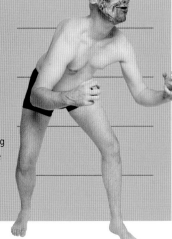

■ His weapon arm has been lowered. His other arm would support the shield, so it is kept close to the body.

Quiet you dogs

About to ambush his opponents, the goblin is turning to silence his comrades since their excited bloodlust might cause the alarm to be raised. The forward movement has been arrested for a moment.

■ The arms are raised in a protective gesture, with the head resting against the upper arm.

I beg mercy

Here is an interesting variation on the cowering pose. There is much more exaggeration in the posture, with the body bent down toward the ground. The curve of the back is maintained by the deep knee bend, and both feet are firmly on the floor.

It wasn't my fault

In this pose we can see the cowardly side of the goblin's personality. He bends back, away from the cause of his fear, with both hands raised in a defensive and submissive manner.

■ His face is turned sideways, but his eyes are fixed on the other person or thing.

In for the kill

Here the goblin is about to leap forward in an attacking pose. His weight is mainly on the front leg to enable him to spring on his opponent.

■ His hands and arms are in a position to grab, tear, and rend.

■ The head and shoulders are thrust forward, leading with the weapon arm, to create a dynamic yet sneaky pose.

Into battle

Although striding forward, this posture is still suggestive of the goblin's natural tendency to skulk and slink along.

Clothing the figure

Under the armor
Beneath the armor the goblin wears a grubby linen shirt, heavy and coarse breeches, and open-toed sandals.

Top layer
The cuirass is made from lizard skin with fur shoulder pieces, and a necklace carries trophies from previous battles.

Added protection
The goblin wears a helmet, plate metal single-arm protection, a mail tasset skirt, and leather shin protectors (greaves). A rough cape is attached to the cuirass.

Wardrobe and weapons
Goblins dress in grubby, rough, and dirty-colored clothes. They do not wash and encourage a filthy and disreputable appearance to intimidate others. They will steal clothing and armor from the dead and wounded and present a mix of styles and apparel. They prefer close-combat weapons, designed to inflict nasty wounds.

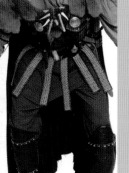

front	side, right

Finish him off

■ Here the goblin prepares for the killing blow, with his eyes fixed on his opponent. Note how the leather armor moves in relation to the wearer.

■ The saber is held sideways to the body—because it is a curved weapon, it needs to be able to make a full arc rather than a thrust to be effective.

three-quarter, front	side

Blow to the head

■ Here the goblin is protecting himself from a downward blow. Using his sword to parry in this position, he can push the attacker's weapon to one side, bring up his shield, and get ready for a counterblow.

■ Because he leans to one side to brace himself against the attack, the weight of his upper body is taken by the kneeling legs.

■ The back leg is pulled in toward the body to help maintain balance, and will also allow the goblin to absorb the force of the attack.

side, left

■ The chain mace is being used defensively to protect the goblin from any upward strike.

three-quarter, back

■ The heavy cape has fallen back from the shoulders. The tension is contained in the upper part of the body, and the main movement will come from there.

■ The position of the legs and feet gives stability.

front

■ This is the farthest the upper body can bend sideways. Any additional movement downward would cause a loss of balance.

back

■ The rear view shows the curvature of the back and shoulders needed to maintain this stance.

■ It also shows how a cape can follow the contours of the body and enhance the pose.

Making faces

Goblins are obsequious and servile to those who command them, and vicious and cruel to those weaker and defeated. They are sly and untrustworthy, something that should come across in any representation.

Yours to command

The turn of the head and the drawn-down brow emphasizes the devious and guileful aspect of this character.

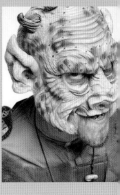

What shall I do?

The furtive turn of the head and the eyes tells us that he is constantly scheming against his comrades, and alerts us to his deceitful manner.

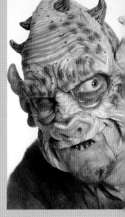

Scream of triumph

Mouth wide open, eyes bulging, the goblin hopes to terrify others with the cry of the chaos hordes. Added to his bestial features, this should cause fear in others.

Classic poses

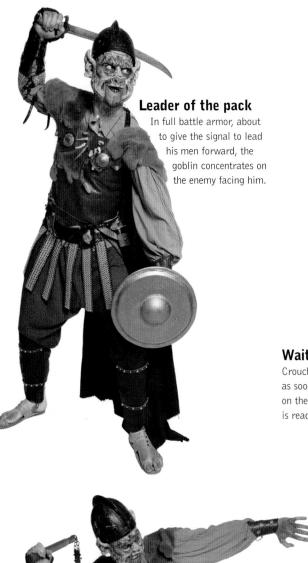

Leader of the pack
In full battle armor, about to give the signal to lead his men forward, the goblin concentrates on the enemy facing him.

You want a fight?
Slowly drawing his saber, the goblin hopes to scare his opponent into backing down.

Waiting for the attack
Crouched down, about to run forward as soon as the order is given, the look on the goblin's face shows he is ready to maim and kill.

Deadly swing
The chain mace is mainly an offensive weapon, designed to inflict as much damage as possible. Because of the nature of this weapon, a clear field is needed for it to be used properly, since long sweeping movements have to be made for maximum effect.

■ The goblin's arm is thrust out to keep his opponent away and give him the space he needs.

Night patrol

With his cape wrapped around him for extra warmth and to blend in with the darkness, the goblin prowls stealthily along. His hand grips the sword beneath and the shield is held out, ready for use.

Final thrust

This is a killing blow, usually against a wounded or disabled opponent. There is a tautness in the arms and shoulders revealing the effort behind the force of the strike. The body will bend forward as the arms and weapon come down and reach waist level.

Sneak attack

This pose shows the furtive nature of the goblin. He would prefer to catch his enemy by surprise, in the hope that he won't put up too much of a fight.

■ The bend of the knee allows movement to be made quickly in either direction.

Close combat

The goblin has lost his shield and is using his saber to block and parry. This allows him to use the chain mace to attack.

Close-ups

Expressions

The depiction of emotion and facial expressions is an important and necessary skill that the fantasy artist must develop and constantly refine.

Contented

■ When contented, the head tends to tilt to one side. The person feels safe and secure, so the body relaxes.

■ From this angle you can see there is a slight drawing back of the lips, but not quite a smile.

■ The female face, particularly when younger, is softer and rounder than that of the male.

■ The eyebrows are thinner and the lips are fuller. Soft flesh tones and full lips add the feminine touch.

Happy

■ On a happy face the brow is raised, the eyes narrow, and creases form at the sides of the mouth.

■ How wide the lips are drawn back when smiling informs the viewer of just how much joy is being felt.

■ The wide upward turn of the mouth is mirrored in the eyes.

■ The top lip is drawn back to reveal the upper row of teeth, which gives the face the appearance of being fuller.

Jubilant

■ When depicting powerful emotions, use highlights to emphasize the forehead, nose, cheeks, and tip of the chin.

■ The highlights accentuate the depth of the expression by throwing the shadows into relief, and add drama.

■ The open mouth of this smile conveys the possibility of vocalization, as if the character is shouting for joy.

■ The extra emotion in this expression causes the lines on the face to look noticeably deeper and the chin to drop.

Baffled

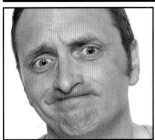

■ When the character is baffled, the eyeline is likely to be unfocused, as if gazing into space.

■ The tight lips and furrowed brow indicate a conflict of thoughts and feelings. Note how the chin is drawn in.

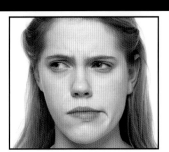

■ Pulling the lips to one side can indicate the process of pondering, and suggests indecision.

■ Sometimes subtle emotions require overplaying to make them more obvious.

Who knows?

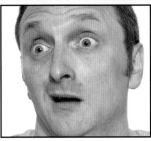

■ When the eyes are wide with surprise, the whites are more noticeable than usual.

■ The angle of the lips is a subtle visual signaling system, and the lips move in relation to the eyes and forehead.

■ Depicting lots of white around the pupils draws attention to the face.

■ A quizzically raised eyebrow helps convey the necessary emotion.

Thinking

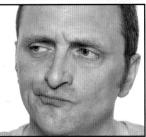

■ When deep in thought, a person often becomes oblivious to anything else.

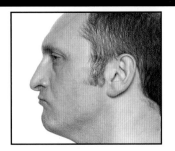

■ Pursed lips and a thrust-forward chin accentuate the impression of physical effort being made to aid cerebral pursuits.

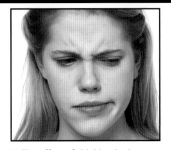

■ The effort of thinking is shown by the frown lines on the brow and the tight upper lip.

■ The slight squint and firm chin, combined with the tension in the mouth area, depict the character's deliberation.

Shocked

■ Sudden shock causes a sharp intake of breath. The mouth opens, the eyes widen, the pupils dilate, and the face turns pale.

■ The head pulls back in fear and the neck muscles tense, while the facial muscles become slack and the whole face droops.

■ Shading the sides of the face can enhance the shocked effect by drawing attention to the eyes and mouth.

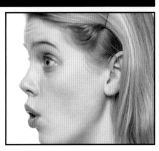

■ If this were a frightening shock, the mouth would be drawn down at the sides, rather than pursed and full as here.

Afraid

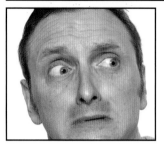

■ In silent fear, the lips will tensely retract until they form a slit, while the eyes dart around looking for safety.

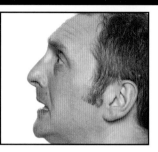

■ The corners of the mouth are pulled down, and the head is drawn down toward the shoulders for protection.

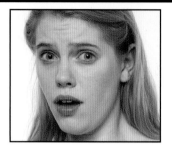

■ Fear causes rapid breathing, which in turn causes the face to lose color, and the eyes will fix on the threatening object.

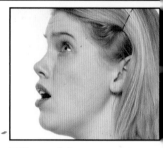

■ The mouth is open ready to scream, and the stare is intense.

In pain

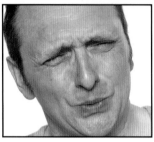

■ Wincing in pain causes the eyes to screw up and the muscles around the mouth and forehead to tense. The head will also drop.

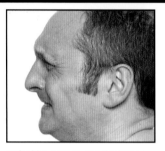

■ Sudden pain causes the lips to pucker up, while sustained discomfort makes them draw back to allow release of breath, as here.

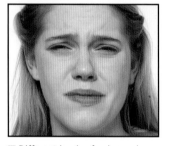

■ Different levels of pain can be suggested by how much the face tenses up. Puckered lips evoke less pain.

■ How much the eyes screw up is also indicative of the intensity of the pain felt and the suffering involved.

Agony

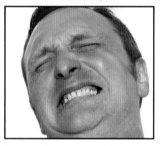

■ When the character is in agony, the whole face will be contorted. An open mouth shows the teeth grinding together.

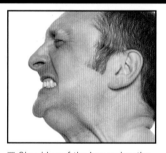

■ Clenching of the jaw makes the neck muscles bulge, and blood drains from the face, causing it to go pale.

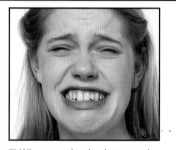

■ When experiencing intense pain, the neck tendons drag the mouth down and sideways.

■ The muscles of the neck react to the pain, and the amount of hurt being felt can be shown by how tense these muscles are.

Smug

■ A supercilious expression is created by tilting the head back and literally looking down the nose at the object of contempt.

■ The mouth and lips can enhance the expression with a lopsided smile. The pushed-out chin suggests a sense of superiority.

■ A humorless smile also gives a sense of superiority. The eyelids are lowered so that it is difficult to see the eyes.

■ The smile is insincere because the cheek muscles are not being used.

Worried

■ The attention of a worried person is elsewhere. The lips pull taut, the eyebrows are drawn down, and frown lines are evident.

■ The lack of direct eye contact, and the tightness around the mouth show pensive distraction—sweat added to the brow helps.

■ The whole face should show worry and concern. The teeth chewing on the lip make excellent visual shorthand.

■The eyebrows are pulled down and the bottom lip juts out, making it obvious that attention is elsewhere.

Depressed

 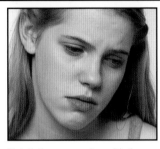 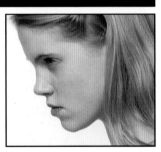

■ When a person is depressed the whole face becomes slack. The color drains away and the mouth and eyelids drop down.

■ The head will lower, but how far down depends on the level of dejection involved. The jaw and lower lip remain limp.

■ A listless expression with the corners of the mouth pulled down suggests depression. Eye contact is avoided, and tears can well up.

■ The neck muscles relax and the head appears too heavy for the shoulders, creating a feeling of lethargy.

Threatening

 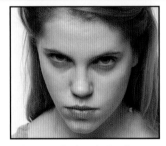 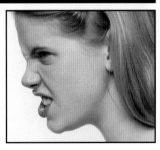

■ In a threatening pose the head is tilted down, but the eyes look up, and attention should be drawn to the hard stare.

■ The tautness of the face makes the features angular and aggressive. The thin lips accentuate the depth of feeling.

■ Because the female face is softer and rounder than that of the male, the threat must come from the eyes.

■ The intensity of the stare will be improved if the shading around the eyes is deepened. There are also deep shadows on the forehead.

Aggressive

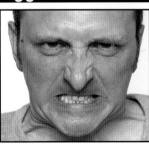 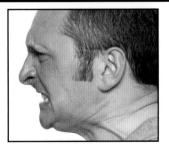 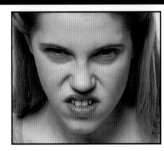

■ Neck tendons tense with anger, and the face reddens with hyperventilation. The veins on the side of the forehead will stand out.

■ The face is thrust forward, the brows are pulled down, and the hard stare is directed at the object of rage.

■ A snarling mouth can be added to the threatening stare. The lips reveal the teeth beneath, while the nostrils flare out.

■ The lines from the nose to the chin will deepen with this expression. The jawline is tense and the face is pushed forward.

Hands

The usefulness of studying hand positions cannot be stressed enough. Of all the parts of the body, the hands are the most active, and a realistic representation of their various functions is essential.

Peasant Girl

■ This pose shows the weight of the coins in the cloth purse and how it should be held and opened.

■ The peasant girl's hands, although feminine, should look as if they have done their fair share of hard work, so no very long fingernails.

Peasant Boy

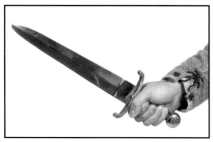

■ The peasant boy has nimble fingers and roughened hands. When he holds the dagger his fingers do not overlap.

■ Allowing the coins to fall, the positioning of the hands places emphasis on the coins themselves and creates a sense of movement.

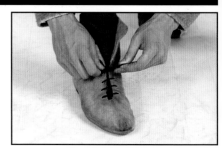

■ This is an excellent reference point that can be used as an example for hand positioning when tying ropes, capes, and drawstrings on pouches.

Warrior Prince

■ The warrior prince has strong, powerful hands and muscular arms. This imperious, commanding gesture is one of resolve and authority.

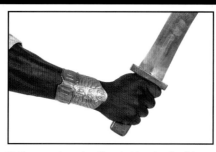

■ The sword needs a firm hold and a flexible wrist, and the hand should hold the weapon at a lowered angle.

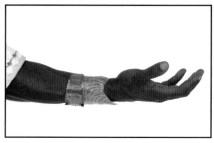

■ This position suggests encouragement and friendship. The positioning of the fingers makes it a motioning gesture, not a holding one.

Princess

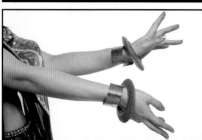

■ The princess has long, slender arms and fingers, and can be given long colored fingernails for added dramatic effect. Her metal bangles emphasize her delicate hands.

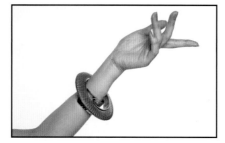

■ For pointing gestures, make the outstretched finger longer than average, which helps to give it prominence and draws the eye toward it.

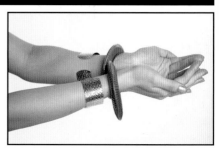

■ Cupped hands can be made more interesting by deliberately not positioning all the fingers close together, and gaps can be used to play with light and shade.

Warrior Dwarf

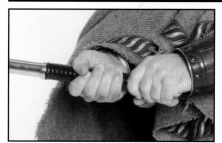 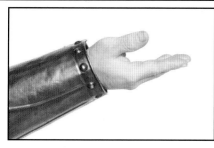 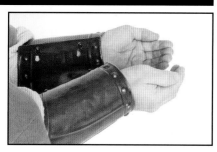

■ When depicting the weight of a weapon, remember that the knuckles of the hands turn pale with tension, while the tips of the fingers get redder.

■ Note how the highlighting on the thumb continues onto the metal of the vambrace, and that in this position the slightly raised fingers give a good sense of depth.

■ The dwarf has short, thick fingers, and using heavy lines and deep shadow areas will make them look strong and solid.

Elven Queen

 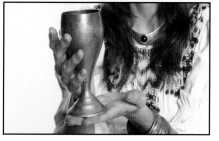

■ The elven queen's hands have a pale, ethereal appearance, and the fingers can be made longer and thinner than usual to create an otherworldly look.

■ In this position the foreshortening of the hands and the way in which the goblet is held suggests movement toward the viewer, as if an offering is being made.

■ Here the hand is not being used to apply pressure; instead, the way the fingers rest lightly on the head could depict thought.

Cleric

 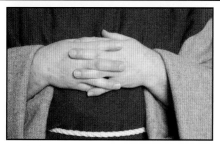 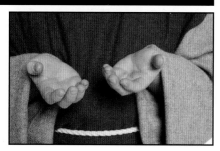

■ The cleric's hands are soft and chubby. They should be ruddy with short nails and squared-off fingertips.

■ When resting flat, the nails and finger joints are emphasized and the whole hand takes on a wide, flattened aspect. Pinker areas show where pressure is greatest.

■ This hand gesture is made more interesting by positioning it directly toward the viewer. Foreshortening of the fingers gives the pose a sense of weight and depth.

Norseman

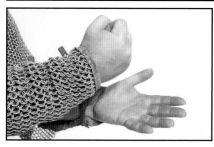 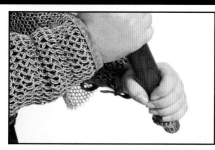

■ Images such as this can be made more interesting by angling away from the viewer. The sideways angle of the pounding fist gives the pose more power.

■ This pose shows the correct positioning of the hands when using an ax. Note that the thumb does not overlap the fingers.

■ The hand position here is angled and better suited to a full-on view of the character.

Evil Sorcerer

▪ Plenty of dramatic tension, with distortion and exaggeration of the fingers and positioning of the hands, creates a sinister effect.

▪ The highlights on the emblem and ring break up the black leather gloves, while the ornate braiding makes a close-up of the hand visually interesting and adds a splash of color.

▪ The highlighting on the gloves shows the position of the fingers and angle of the hands. Highlights can show dark objects against a dark background.

Wizard

▪ The wizard is an older character, so his knuckles and finger joints are more pronounced than those of his younger counterparts. From this angle the ring is prominent.

▪ The grip on the staff is firm, but the ring finger is slightly higher than the rest, again drawing the viewer's eye to it.

▪ The wizard's fingers are long and slender, with prominent veins. Slim, mature people tend to have quite thin skin, and the bones beneath stand out.

Fairy

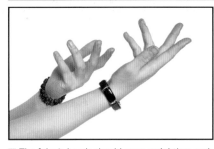

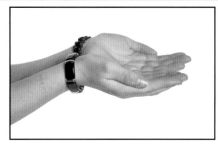

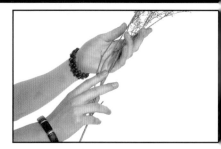

▪ The fairy's hands should seem weightless and delicate, almost as if there is no solid bone beneath the skin. Her hand gestures should be refined and not at all aggressive.

▪ Even held in this position it seems that the fairy's hands would be incapable of holding any real weight. They should look as if they might float away.

▪ The placing of the fingers is important, since the way an object is held should reinforce the light, airy feeling. Here her hands are barely touching the flower stems

Barbarian Warrior

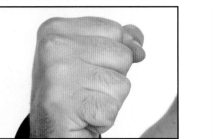

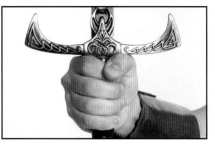

▪ Powerful hand gestures portray the nature of the warrior. From this perspective the fist comes right at the viewer, and whitened knuckles emphasize the tension held in the hand.

▪ When holding a sword the thumb should lay slightly over the index finger, to allow the hold to be maintained when the sword is used.

▪ This pointing gesture is extremely powerful because it comes directly at the viewer. The shading and foreshortening give it the necessary three-dimensional effect.

Goblin

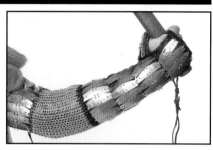

■ The studded leather wristband supplements the balled fist's strength and power, and will also cause the veins in the hand to swell. Highlights show the direction of movement.

■ This position shows how the armor is fixed to the hand and arm. Incidental detail such as this is necessary to create a sense of reality.

■ Steel and iron have a duller shine than brass or gold, and the way the plates catch the light changes with the position of the arm.

Warrior Woman

■ The female equivalent of the barbarian warrior should have slightly smaller hands than his, and her skin is less coarse. Note how the thumb is tucked in too.

■ The grip here is relaxed as the sword points downward. Any pressure would cause the lines to deepen, and the thumb would move to a lower position.

■ When depicting a character with dark skin, remember that the palms are a lighter shade than the backs of the hands. Here the deep creases express the amount of force applied.

Wicked Sorceress

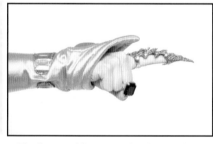

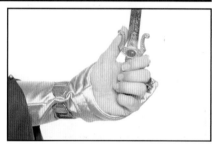

■ The decorated finger guard with its spiked end gives a threatening feel to the pointing digit, and makes hand gestures suitably dramatic.

■ Note how the hands appear to caress the crystal ball. The thumb of the upper hand is raised for a better view, which suggests concentration.

■ The slightly clumsy way the dagger is held implies that the user does not rely on weapons and is not sure of how to use them.

Elven Warrior

■ Like his female counterpart, the elven warrior should have fair hands, with long, sensitive-looking fingers that taper slightly at the tips.

■ The process of adjusting the vambrace is made easier if the hand is flat; however, having the fingers slightly parted and raised makes a casual pose more interesting.

■ The grip for holding a bow is similar to that for holding a sword. The vambrace is pulled lower, protecting the wrist from being cut by the bowstring.

Accessories

Accessories can personalize a character, denote status, and enhance a scene. A good working knowledge of how clothing and armor move and how metal, leather, and jewelry reflect light is essential.

Peasant Girl

■ The cloth belt with hanging purse is worn on the hips, giving it a jaunty look.

■ The simple homemade necklace could have been made by the peasant girl herself, or perhaps it was a gift from an admirer in the village.

Peasant Boy

■ The boy's cape is held at the neck by a decorated metal clasp, which allows it to rest on the chest rather than at the neck.

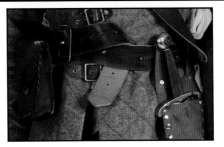

■ A thick decorated belt, with a leather pouch and dagger hanging from the studded belt frog, is worn high on the waist for ease of access.

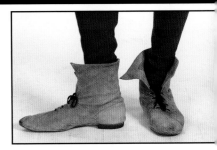

■ His soft suede boots have a slight heel. Note the creasing around the ankle area, showing movement and use.

Warrior Prince

■ A short sword in a scabbard is worn on the left side, carried on a shoulder sling. This is both decorative and practical.

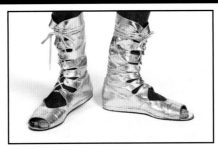

■ Gold leather, booted sandals denote wealth and status, but are also practical and comfortable for a warrior to fight in.

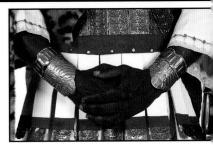

■ Beaten gold wristbands have sacred or heraldic designs embossed on them. They are both decorative and defensive personal items.

Princess

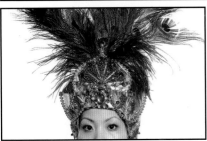

■ This ornate headdress allows the artist to work with dramatic highlights and shadows, and movement can be depicted by bending back the peacock feathers.

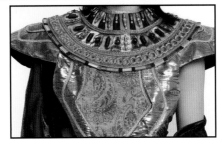

■ A decorated collar and tabard makes the princess's figure imposing, and the interplay between richly textured material and skin can produce interesting effects of light and shade.

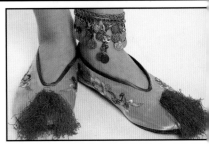

■ Soft silk slippers without wear show that the princess does not undertake much walking. The ankle bracelet adds to the personality of the character.

Warrior Dwarf

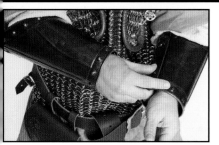 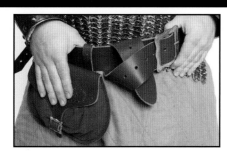 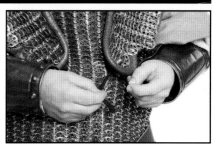

▨ The metal armguards have been burnished to darken them down, and the light picks out the raised details—this effect, of course, will change with the direction of light.

▨ The wide leather belt has the excess passed under and over, and the buckle is pushed to the side, with the pouch on the other side.

▨ The shoulder pieces of the scale armor are held in place with leather ties. Notice that the tips of the scales are highlighted so detail is picked out.

Elven Queen

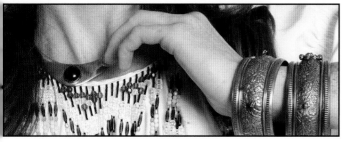 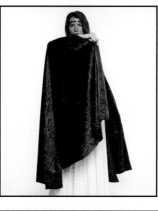

▨ Capes can be used to create an air of mystery and to suggest movement and motion. It is important to stress that there is a solid body beneath.

▨ Jewelry, torques, bangles, and such add to the general look of the character and can enhance and personalize any depiction of her.

Cleric

▨ The cleric's wide leather belt pulls his tabard tight across his body, causing creasing at the sides.

▨ The short sword lays forward to make it easier to draw from the scabbard, and the tabard is kept clear.

▨ A pouch for personal items can either hang low and look bulky with coins to suggest wealth, or sit flat and high to show poverty.

▨ Clerics mainly travel by foot, so their flat, soft-leather, closed sandals should have a worn, well-used look.

Norseman

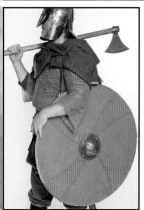

▨ The Norseman's circular shield has a crooked cross design. Shield designs are an important aspect to consider since they can indicate the personality of the user.

▨ A bone-handled hunting knife sits in a soft leather sheath. Note that the mail shirt does not crease due to weight but hangs over the belt.

▨ The Norseman's long belts have ornate buckles, and a loop over is made to prevent excess hanging. Note how the belts rest on each other.

Evil Sorcerer

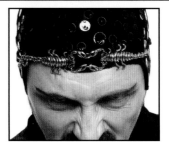

▨ The use of accessories, such as capes and sashes, can break up the silhouette and make poses more interesting.

▨ Magic medallions and talismans are important to sorcerers, and artists can create unusual and eye-catching designs for them.

▨ The leather skullcap has metal studs that allow light to play on it. This texture enhances the effects of light and shade.

▨ Leather boots will drop slightly when worn, and the creasing around the ankles deepens with exaggerated movements.

Wizard

▨ Heavy folds show the thickness of the cloth where the belt is pulled in.

▨ The artist and illustrator should take care to create a feeling of solidity and weight in any depiction of a bag.

▨ Being bright against the gray material, the potion bottle and amulet with eye motif grab the viewer's attention.

▨ The creasing of the well-worn leather shoes, with flat soles, follows the line of the toe and ankle movement.

Fairy

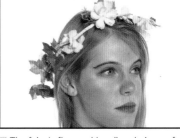

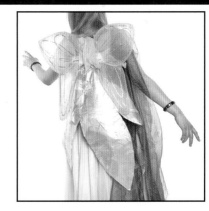

▨ Her wings should have the appearance of thin gossamer, so that light passing through them creates a rainbow effect.

▨ A subtle change of color in the dress gives it a magical and ethereal feeling, while the silver rope belt adds a little weight.

▨ The fairy's flowered headband gives a feeling of oneness with nature and makes a simple but effective decoration.

Barbarian Warrior

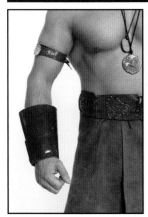

▨ Wrist- and armbands can be used to emphasize the warrior's muscles. The armband should be tight against the flesh to suggest the strength of the arm.

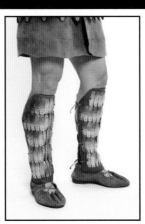

▨ Metal plate greaves protect the lower legs, and the separate plates allow for greater movement than solid metal. This allows the artist to depict more extreme fighting poses.

▨ A leather headband is used to keep hair or sweat out of the eyes. It can also designate rank and status. Decoration on the band makes it visually interesting.

Goblin

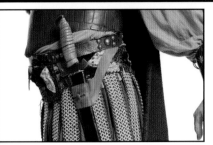

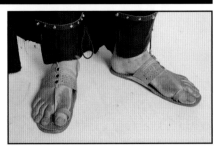

■ The saber hangs from the belt and the scabbard is held in a frog. A sword holder worn over the shoulder is known as a "baldric."

■ The trophies on his bone-and-tooth necklace show the goblin's cruel and barbaric nature, and add to his frightening appearance.

■ Flat-soled sandals cause the feet to splay out and look quite large, and remember that feet wearing sandals get very dirty very quickly.

Warrior Woman

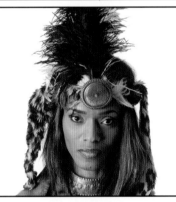

■ The animal-skin headband with metal brow piece and tall feather give a sense of barbaric, savage splendor to this character, and make her all the more imposing.

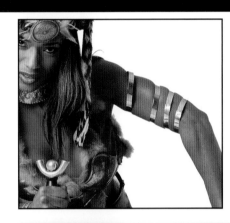

■ A metal upper armband draws attention to the warrior's strong arms, and acts as protection as well as decoration.

Wicked Sorceress

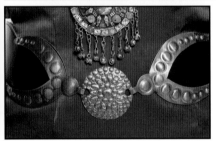

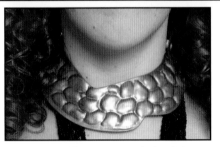

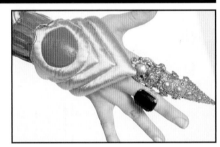

■ The metal parts of the girdle belt have a similar pattern to the neck torque and create a matching look.

■ Interesting effects are created when light catches the surface of the sorceress's beaten-metal torque.

■ The shape of the cuff of the dress mirrors and complements the finger decoration, as well as making the hand look longer.

Elven Warrior

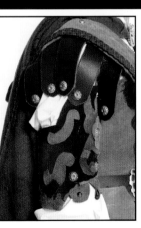

■ The leather shoulder strips are weighted down with brass studs, and the decorated upper arm guard is attached to the tunic, allowing free movement.

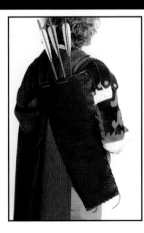

■ The arrows are carried in a leather quiver, which has bulk but not a lot of weight. The strap is carried over the right shoulder.

■ The elven warrior carries his pouch and dagger on a belt of the same material as his tunic, which the sword belt rests upon.

Lighting

The use of light and shade in your fantasy artwork is of paramount importance, creating mood, adding drama, and enhancing images. How light falls on the face can alter the feel of a pose, and careful study of light direction and strength will produce striking effects.

You will also find that the different aspects of light evoke varying dramatic responses. For example, shadows create a real sense of drama, particularly in scenes depicting evil characters in dungeons, caverns, and throne rooms, whereas a soft-focus approach evokes a subtle, romantic feeling, softening and flattening hard edges and facial details.

Direction of Light

Uplighting

From above right

■ Light coming from below will tend to give the features a sinister aspect, which is ideal for villains and evildoers.

■ The highlighting of the areas under the forehead makes the eyes prominent, and the shadows cast above the cheeks draw in the face.

■ The angle of light from above right has given the contours of the shoulders and chest more definition, and the face more shade.

■ It is important to deliberate on what source the light takes. Candles, lanterns, and moonlight will have different densities.

From front right

From above

■ Side lighting allows emphasis to be placed on single areas of the face. Note how the nose and chin, when lit from the right, cast a deep shadow.

■ The rounder female face causes shadows to form in different areas, directly under the nose and the eyes being deepest.

■ Faces hidden in shadow can give a sense of mystery and peril, and picking out a few details is most effective.

■ Although the face is in shadow, highlights on the hair and tip of the nose throw the eyes into relief.

Types of Lighting

Natural light

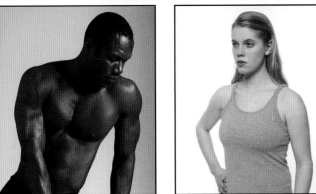

■ Natural light is neutral in color, and the difference in light and shadow is evenly balanced. A neutral light allows all areas of the pose to be seen.

Colored light

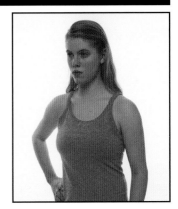

■ A colored light source will affect the object being illuminated. Blue light will give a cold feeling, while red or yellow light will warm the scene.

Silhouette

■ Backlighting accentuates shape. With light directly behind them, the characters will become silhouettes, but allowing a little light through will show the details of the pose.

Abstract light

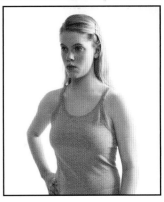

■ Abstract light allows for a more interesting play of light and shadow, because the source comes from several directions and levels.

Dim light

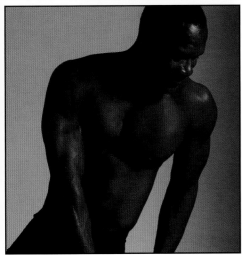

■ With dim lighting, dark colors blend into each other, and only the lighter areas remain visible, with shadows becoming softer edged and deeper.

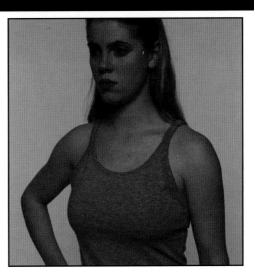

Dramatic Lighting

Creating shadows

▨ The combination of deep shadows, light on the face and hand, and foreshortening gives the pose a three-dimensional feel.

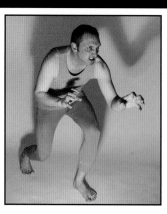

▨ The change of angle places more emphasis on the shadow cast by the model and adds to the threatening feel.

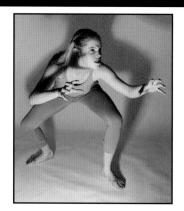

▨ Shadows can be used as an extension of the pose, or distorted to produce interesting effects and unusual compositions.

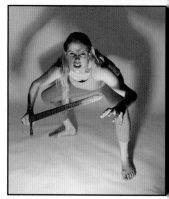

▨ This stance is made more forceful because the shadow seems to loom and grow with a life of its own.

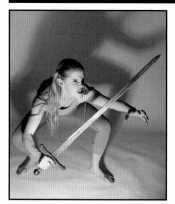

▨ Here the shadow acts as a framing device for the pose, drawing attention to the model's facial expression and weapon.

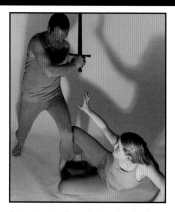

▨ By having the attacker in shadow and the victim in light, attention is placed on the prone figure, creating anxiety.

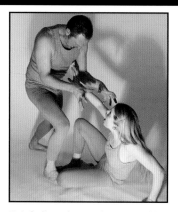

▨ A feeling of terror is prompted by the way the attacker's shadow looms over the victim, and the way their shadows merge.

▨ Putting the male figure in silhouette places attention on the female. This can create an aura of ambiguity and mystery.

Soft focus

▨ Muted tones and diffused light create the feeling of a warm and safe environment where love can blossom.

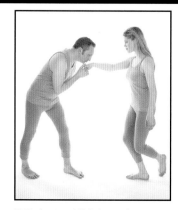

▨ Understated lighting and an indistinct background put emphasis on the characters, making them the center of attention.

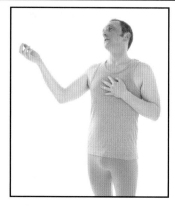

▨ The emotion being depicted here is accentuated by the way the gentle lighting takes away any hard lines.

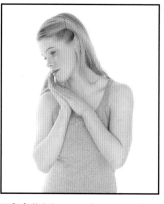

▨ Soft lighting can also suggest the inner glow of someone deeply in love. Note how it flatters the features.

Natural light | Creating atmosphere with colored light

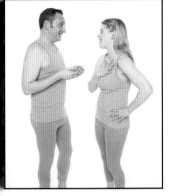

▓ Natural light is useful for showing straightforward scenes. It gives a neutral look, showing detail evenly.

▓ Colored lighting can evoke diverse moods. Dark colors are ominous and mysterious. They deepen shadows and cause colors to become duller.

▓ Blues, edging into grays, are most suitable for night scenes, dungeons, and prisons. They give the impression of a cold and hostile atmosphere.

▓ The use of murky and gloomy lighting produces a heightened feeling of terror, with the possibility of enemies hidden in the shadows.

▓ The surrounding gloom gives the fleeing duo's backward glance a sense of trepidation, particularly since their faces are still visible.

▓ Yellows, reds, and oranges embody heat. The deeper the color, the greater the intensity, causing other tones to bleach out.

▓ Firelight will flicker and move, so the campfire that your character is warming by will create distorting highlights and deep shadows.

▓ A constant strong light source will allow some modeling. Figures will become hard edged with sudden color graduation and tones.

▓ A concentrated burst of light will flatten out detail so that only deep shadows remain, and the eyes will be the most noticeable feature.

▓ A steady source of illumination will allow more features to be seen. Darker tones and colors will stand out more than lighter ones.

Now Go Paint

Comradeship

Scenes of camaraderie can be as inspiring as those depicting battles and fighting. Fantasy art should not be all death and destruction. Arranging figures and getting them in the right perspective and scale to each other is an important starting point for building an attractive and meaningful composition.

Ales and tall tales

Illustrating social situations and everyday scenes allows the artist to explore every aspect of the fantasy world and helps to create a fully rounded concept of an alternative universe of mystery and adventure. How each character interacts with others gives clues to the different aspects of their personalities.

◼ The Norseman and cleric are obviously having trouble taking the peasant boy's story seriously.

◼ The triangular arrangement of the characters helps with the narrative flow. The viewer is led from the serious attitude of the peasant boy to the bemused Norseman, then to the laughing cleric. Each one complements the other.

◼ The careful use of gesture and positioning can add to the composition of a picture. The emphatic hand gesture of the peasant boy leads the eye to the other characters.

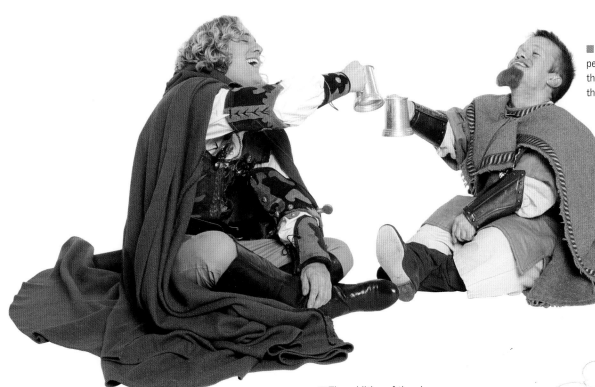

■ Note that when people are seated they are roughly the same height.

■ The addition of the ale splashing out of their tankards gives a sense of movement and tangible joy.

Here's to us!

Deciding what sort of location to place characters in can also affect the interpretation of their actions. The elf and warrior dwarf could easily be indoors or outdoors, in an inn or a castle, on a beach or in the woods—at day or night. Light and shade and the general mood are affected by the physical environment that characters are placed in. In this sketch, they are depicted sitting on a rocky outcrop in the open air. This gives a happy, warm, and sunny feel.

My lady, my love

Showing tenderness and affection can be a real challenge. Facial expressions, eye contact, and attitude can reveal different levels of attraction and intimacy. These can range from shy, sidelong glances, to full, adoring looks of love and devotion. Obviously the amount of physical contact portrayed will show the intensity of the characters' feelings for each other.

■ The boy is bowing his head. His submissive attitude—too nervous to meet her eyes—shows he is sincere.

■ The peasant girl looks apprehensive. Are his intentions honorable?

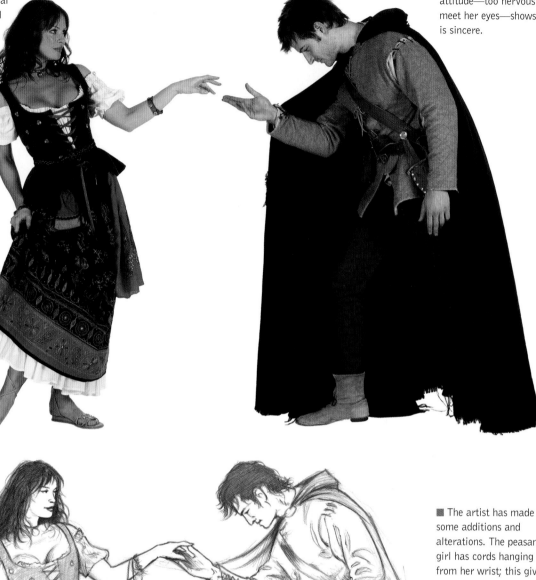

■ The artist has joined the hands of the boy and girl. This creates a greater emotional impact.

■ The artist has made some additions and alterations. The peasant girl has cords hanging from her wrist; this gives weight to her arm and adds to the flowing movement. The peasant boy's cloak is more ragged and worn, giving it an interesting texture.

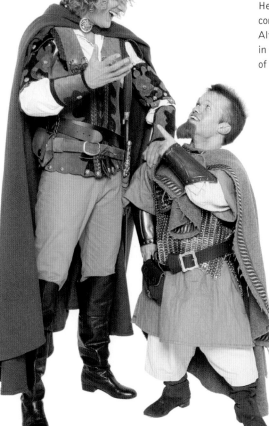

■ Combining opposites creates visually arresting images.

No, you're much braver than I am!

Here the elven warrior and warrior dwarf congratulate each other on their battle prowess. Although there is an element of humor and mockery in their attitude, their body language shows the depth of their friendship.

■ Proportions can be emphasized and exaggerated for dramatic effect.

Just one more, please

This character and pose could be played for outright comedy. The cleric's bulky body and his love of food, drink, and comfort are evident from the way his considerable girth is sprawled out. The fairy trying to admonish him adds to the comical feel of the pose.

■ The use of the fairy gives a good indication of her size and scale in relation to other fantasy archetypes.

■ His clothing is in disarray, creating interesting variations of folds, creases, and textures.

Fighting and Combat

Depictions of battle and warfare are the mainstay of fantasy art, whether it be one-to-one combat or conflict between the forces of good and the mass hordes of chaos. Pitting different figures against each other allows you to create interesting and unusual combinations.

■ Be sure to emphasize taut and bulging muscles, particularly in the arms, because this shows the physical exertion involved in fighting.

Block and parry

Curved weapons, such as sabers, need a wide arc to be effective. For maximum damage the blow should come from head height.

■ Make sure the adversaries' eyes meet. Staring out your enemy is an important psychological factor.

■ The barbarian uses the sword as a shield, to block blows and push away.

■ Using two weapons means the goblin will be more reckless and destructive in his attack.

Attack and counterattack

Convincing body positions are essential in depicting fight scenes between characters. The fighters should move forward and back, as well as from side to side and diagonally, and their footwork is used to avoid blows and to close in for attacking.

■ The goblin holds the saber to both block and knock away the barbarian's sweeping sideways blow.

■ Bodies can undertake extreme postures, such as twists and turns. A certain amount of exaggeration makes a pose more forceful.

■ Facial expressions should give clues to the combatant's mood, for example savage anger, elation in victory, or distress in defeat. The addition of sweat, wounds, and blood also adds to the intensity of feeling and the impression of a fierce struggle.

Attack stance

Before opponents attack each other, there is a moment when they stand ready, sizing up each other's strengths and weaknesses. Showing this can create a real sense of dramatic tension.

■ Damage to weapons is a useful device to show the effort of close combat. Try incorporating tattered helmets, dented armor, and dirty clothing into your illustrations to create a sense of realism.

Necromancy against enchantment

Villains should be able to adopt melodramatic theatrical gestures and poses. It is part of their nature to try to impose their will by making others fear the powers they wield.

■ Here the sorcerer uses both his staff and hands to invoke demons. This is the source of his magic and is both an offensive and defensive weapon.

■ The wizard, on the other hand, is more understated and steadfast, and in many ways the opposite of his evil opponent.

Duel of magic

Depicting conflict between characters with supernatural powers allows the artist to experiment with light and color. Here the good wizard conjures an attack spell directed at his evil adversary.

▨ The evil sorcerer winces with pain as the spell envelops him.

▨ Intense expressions bolster the efforts made in using magic. Casting spells should require the same dynamism as using actual weapons.

▨ The artist has added eldritch fire leaping from the hands of the wizard to show the spell taking effect.

Sword versus sorcery

The sorcerer wields his staff of power. Props like this can be used to establish points of interest and draw the viewer into the action. Magical objects shining with mystical radiance can also be used as the light source to illuminate a scene and produce unusual light and shadow effects.

■ The evil sorcerer must rely on his magical powers. Without them he is a poor opponent in hand-to-hand combat. The jewel at the tip of his staff should glow with magical light.

■ The wizard's sword could be made more interesting by surrounding it with a magical glow.

It comes to weapons

Having exhausted their magical powers, the two masters finally fight it out with sword and dagger—but first the wizard must find his opponent!

■ This pose could be made even more visually exciting by having the other hand surrounded by a nimbus of light, suggesting that they are saving their remaining magic for the final decisive blow.

■ Showing someone in a three-quarter pose gives them a feeling of solid stability.

Artist at Work

The Fall of the Castle by Anne Stokes

The artist has chosen the dynamic figure of the warrior woman and the deformed, evil goblin as inspiration for painting a classic fantasy scenario

Tools and media

Mountboard

HB pencil

Acrylic synthetic brushes in a range of sizes

Artist's sponge

Color palette

Acrylic paints:

 burnt umber

 cadmium deep red

 cadmium orange

 cadmium red

 cerulean blue

 cobalt blue

 cobalt green

 lemon yellow

 mars black

 permanent sap green

 raw sienna

 raw umber

 titanium white

Pencil underdrawing

1 Using the photographic reference, the artist begins by sketching out the basic idea for the composition onto mountboard. She has chosen not to work with paper since she will be using acrylic paints, which, because they are water-based, can warp the paper surface. This first stage maps out the illustration and gives the artist an idea of how the image will work as a whole, providing a good framework upon which to build layers of detail in future stages.

Blocking in

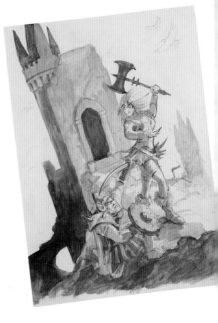

2 Using a synthetic brush and diluted raw umber, the artist blocks in the dark tones and strengthens some of the pencil lines. This prevents the loss of the edges when the blocking in is added.

■ The "watery" raw umber is applied first to establish the tonal levels, and the artist is careful not to obscure the previous linework.

Blending the sky

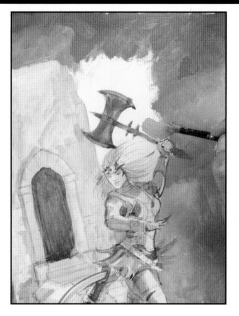

Creating depth

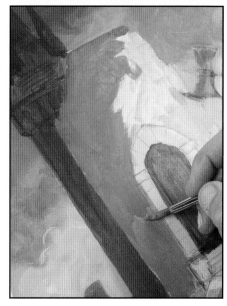

3 The intense, swirling colors of the sky are created by first using an old brush to blend the texture in the clouds. The artist begins at the back of the painting and works in a forward direction. Then, to make sure that the brushstrokes do not show, she uses a finger to blend the paint further.

4 The sky on the right-hand side of the painting is blocked in around the ax. Note that there will be some overlap, but the edges can still be seen. The area around the warrior woman's hair is blocked in so that the strands show through. To allow the figure of the woman to stand out more, the artist lightens the sky behind her.

5 The architectural structures are now blocked in with color. Burnt umber mixed with cadmium orange is used for the structures at the back left of the castle, which creates a sense of solidity and depth. To bring the front tower forward, a mixture of mars black and titanium white is overpainted onto the tower.

Deepening shadows

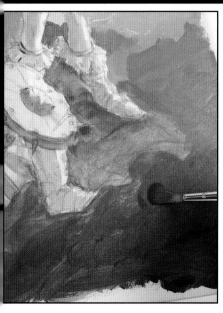

Adding detail

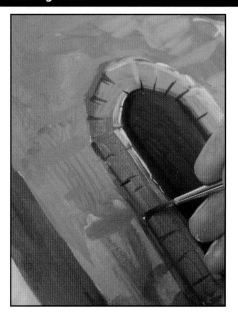

Creating texture in the rocks

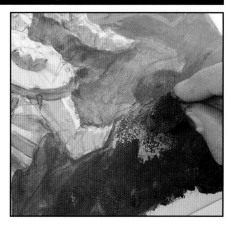

8 Using a sponge, lighter colors such as lemon yellow and apricot (see step 9) are stippled to the foreground rocks to suggest their ragged texture.

6 The foreground shadows are deepened with the addition of a brownish red mixture of paint. This is created by mixing raw umber and mars black.

7 Using a fine brush, the artist adds detail to the stonework of the castle using mars black. This also darkens the areas of shadow.

Artist's tip

Newly purchased sponges are often smooth and don't produce an interesting, textured finish. Try ripping the sponge to let it create an irregular pattern.

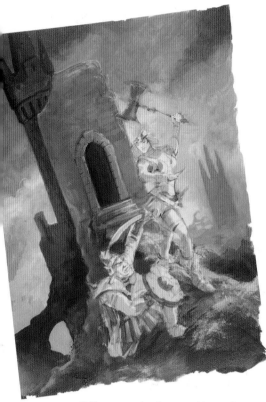

■ The sponge has been used to create highlight and shadow textures. If you make a mistake or are unhappy with the effect created, the sponged paint can easily be rubbed out.

Knocking back

9 Creamy apricot (mixed from cadmium orange, lemon yellow, and titanium white) is sponged over the distant tower on the right to knock it further back into the distance.

Painting the warrior woman

10 Using the fine brush and the apricot mixture, the artist blocks in the areas of flesh, starting with the dark areas and working toward the lighter ones.

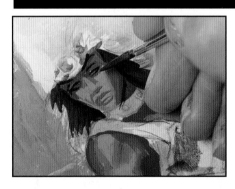

11 The artist uses mars black to add detail to the facial features.

Artist's tip

When selecting figures for a composition you don't have to adhere to every detail of your reference. For this painting, the artist has adapted poses from the book and changed the characters' focus of attention to suit the purpose of the painting.

12 The hair is blocked in with raw umber and lighter tones, and highlights around the facial features and headdress are added in titanium white. Individual strands of hair are then picked out with a mix of burnt umber and lemon yellow, and creamy highlights are added.

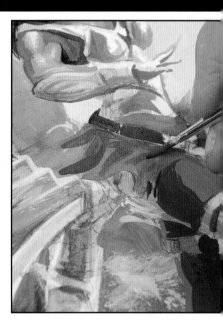

13 The warrior's costume is painted in cadmium orange and raw umber. Note how the colors are reflected in the metal armor she wears on her arm

■ The artist has used mars black and titanium white on the figures and the tower only, because it is these elements of the composition that need to come forward.

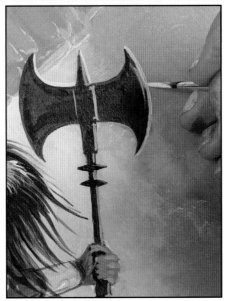

14 Don't be afraid to turn the painting board in order to paint the ax, which requires a curve. A mix of cadmium orange, lemon yellow, and titanium white is used to highlight the edge of the ax.

15 The fringes of the warrior's boots are also given highlights, and the figure is completed by the addition of vertical highlights to the thighs.

Painting the goblin

16 The darker tonal areas of the goblin are painted in first with a mix of permanent sap green and raw umber. Remember that there is not as much flesh on show here as there is for the female figure.

17 Detailing is added to the face using mars black and titanium white. This is added to the original brown-green mixture to make it lighter or darker as required.

18 To add depth to the shield, highlights are applied to the spikes and center.

19 The artist uses her finger to blend the dark shadows behind the figure. Don't be afraid to use fingers for blending and merging colors. You'll soon discover just how much pressure is required to achieve the effect you are after.

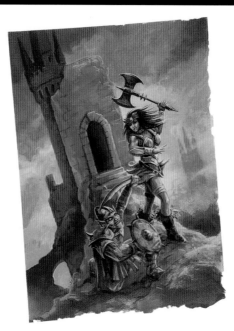

■ The figures have been completed and the artist can now move on to adding the final details that will really bring the image to life.

20 With a fine brush the artist adds more detail to the stonework of the castle. Do not be tempted to overpaint the detail here. You don't want the background to dominate the foreground figures.

21 The sky is made even more dramatic with the addition of more cadmium orange to the apricot mix, which is then blended into the orange-red background.

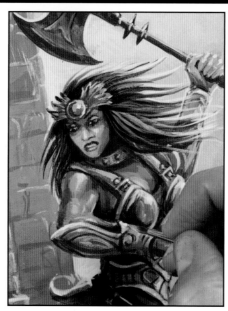

22 White highlights are added to the female warrior's armor.

23 A battle wound on the goblin's leg is added with a fine brush dipped in a mix of cadmium red and cadmium deep red.

The finished painting

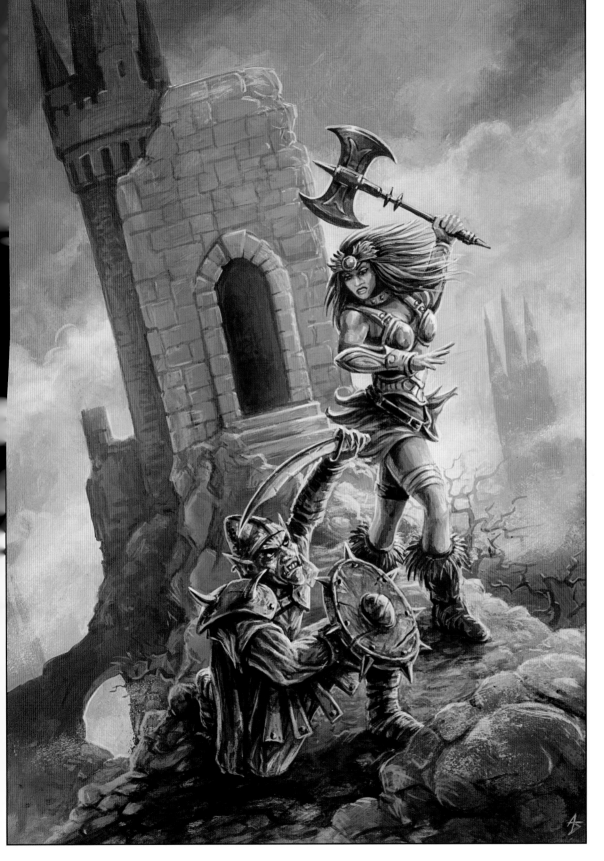

■ Cadmium deep red has been added to the sky to heighten the sense of drama.

■ Twisted branches have been picked out to the right of the female figure. Remember to keep details like this as simply a suggestion of a form, since they remain in the background.

■ Very subtle details have been added under the arch at the bottom left side of the painting, to show texture and roots. These have been painted with diluted raw umber to allow the background painting to show through.

Resources

This is by no means a complete or definitive list, but it does provide a good selection of suppliers and web sites that you may find inspiring, interesting, or informative.

Costume and Historical Weapon Suppliers

Here are some suppliers that the author has found useful:

U.S.

Costume Suppliers

The Costumes Manifesto
A page of very useful links to various sites for costume and arms
www.costumes.org/History/100pages/milita
ryuniforms.htm

J.A.S. Townsend & Son, Inc.
133 North First Street
P.O. Box 415
Pierceton, IN 46562

Weapons and Props

Excalibur Brothers
1434 May Street
Lansing, MI 48906
Tel: 877-496-8152
www.excaliburbrothers.com

Knights Edge Ltd.
5696 N Northwest Hwy
Chicago, IL 60646-6136
Tel: 773-775-3888
www.knightsedge.com

U.K.

Costume Suppliers

The Costume Studio
159–161 Balls Pond Road
London N1 4GB
Tel: +44 (0)207-275-9614
www.costumestudio.co.uk

Weapons and Props

Bapty & Co.
1A Witley Gardens
Norwood Green
Southall
Middlesex UB2 4ES
www.bapty.co.uk

Battle Orders Ltd.
71A Eastbourne Road
Eastbourne
East Sussex BN20 9NR
Tel: +44 (0)8704-430-182
www.battleorders.co.uk

Weapons Galore
Suite 55
60 Westbury Hill
Westbury on Trym
Bristol BS9 3UJ
www.weaponsgalore.com

Re-enactment Societies

Re-enactment societies and fairs are a good way to find items of armor and costume at reasonable prices.

U.S.

Living History Association
P.O. Box 1389
Wilmington, VT 05363
Tel: 802-464-5569
www.livinghistoryassn.org

Northern Medieval Association
P.O. Box 1026
Greenwood Lake, NY 10925
www.northernmedievalassoc.org

The Realm of Chivalry
P.O. Box 23334
Federal Way, WA 98093-0334
www.therealmofchivalry.org

U.K.

Living History Events
David Smith
P.O. Box 56
Wellingborough
Northants NN8 1SF
www.livinghistoryfayres.com

Re-enactors' Fair
Ann Laverick
29 Roundhill Road
Castleford
West Yorkshire WF10 5AG
www.reenactorsmarket.co.uk

Fantasy Art Resources

For both the budding and the more established fantasy artist, the Internet is an essential point of reference. There are thousands of sites dealing with all aspects of fantasy art. Here are some that the author has found useful:

www.masteroffantasy.com

www.swordsorcery.com

www.tuckborough.net/ swords.html

www.fantasy- artists.co.uk/resources.shtml

Further Reading

Cowan, Finlay, *Painting Fantasy Figures*, (Barron's, 2003)

Fabry, Glenn, *Anatomy for Fantasy Artists* (Barron's, 2005)

Hartley, Dorothy, *Medieval Costume and How to Create It*, (Dover Publications, 2003)

Talhoffer, Hans (translation by Mark Recto), *Medieval Combat*, (Greenhill Books, 2000)

Stone, George Cameron, *A Glossary of the Construction, Decoration, and Use of Arms and Armor in All Countries and All Times* (Dover Publications, 2000)

Index

A

accessories 132–135
affection, to portray 142
aggressive expression 127
agonized expression 126
angry expression 31, 57, 63, 87, 93, 115
armor:
 Elven Warrior 36
 Goblin 120
 Norseman 114
 Warrior Dwarf 86
 Warrior Prince 68
 Warrior Woman 30
atmosphere, to create with light 139
ax attack pose 86–87, 114–115

B

baffled expression 125
Barbarian Warrior 22–27
 accessories 134
 hands 130
battle cry expression 25, 31, 37, 87, 101,
 115, 121
block and parry pose 144
blocking in 150
blow to the head pose 120–121

C

casting the spell pose 74–75
Cleric 90–97
 accessories 133
 hands 129
close combat pose 114–115
comradeship poses 140–143
contented expression 124
curtsying 48–49, 52

D

dancing poses 51, 55, 59, 109
defending the battlements pose 68–69
defensive poses 23, 34, 40, 73, 105, 119
depth, to create 151
depressed expression 127
detail, to add 151
drinking poses 45, 94, 95, 97, 111, 117
Dwarf, Warrior 84–89
 accessories 133
 hands 129

E

ectomorph 16–17

Elven Queen 40–45
 accessories 133
 hands 129
Elven Warrior 34–39
 accessories 135
 hands 131
endomorph 14–15

F

facial expressions 124–127
 Barbarian Warrior 25
 Cleric 93
 Elven Queen 43
 Elven Warrior 37
 Evil Sorcerer 81
 Fairy 49
 Goblin 121
 Norseman 115
 Peasant Boy 101
 Peasant Girl 107
 Princess 57
 Warrior Dwarf 87
 Warrior Prince 69
 Warrior Woman 31
 Wicked Sorceress 63
 Wizard 75
Fairy 46–53
 accessories 134
 hands 130
farewell poses 44, 52, 82
fearful expressions 81, 126
fearful poses 48–49, 55, 59, 91, 105
fighting poses 22–23, 29, 35, 66–67, 84–85,
 101, 112–113
 with ax 28, 86–88, 114–115
 with bow 36–38
 with dagger 64, 100–102
 with sword 24–26, 30–32, 68–69,
 74–75, 92–93, 95,
 114–116, 120–123
final blow pose 24–25
flying poses 46, 47, 50
footwear:
 Barbarian Warrior 24
 Elven Queen 42
 Elven Warrior 36
 Fairy 48
 Norseman 114
 Peasant Boy 100
 Peasant Girl 106
 Warrior Dwarf 86
 Warrior Woman 30
 Wicked Sorceress 62

G

gesture 140
Goblin 118–123
 accessories 135
 hands 131
 to paint 153–154
greeting poses 41, 55, 71, 77

H

hands 128–131
happy expressions 49, 69, 75, 93, 107, 124
headgear:
 Evil Sorcerer 80
 Princess 56
 Warrior Woman 30
holding/picking poses 47, 51, 62–63, 67, 99,
 104, 105

I

interaction 140–143

J

jewelry:
 Elven Queen 42
 Evil Sorcerer 80
 Warrior Prince 68
 Warrior Woman 30
 Wicked Sorceress 62
 Wizard 74
jubilant expression 124

K

kneeling poses 35, 36–37, 39, 47, 52, 62–63,
 66, 70, 82, 105, 112
 defensive 23, 45, 55, 59, 68–69, 120–121
 greeting 48–49
 imploring 41, 45, 56–57, 61, 67
 praying 94
knocking back 152

L

laughing poses 82, 83, 90, 97, 98, 113
light:
 abstract 137
 colored 137, 139
 dim 137
 direction of 136
 natural 137, 139
location 141

M
magic combat 146–147
mesomorph, female 10–11
 male 12–13
muscular build, female 10–11
 male 12–13

N
Norseman 112–117
 accessories 133
 hands 129

O
on guard pose 74–75
opposites, to combine 143

P
pained expression 126
Peasant Boy 98–103
 accessories 132
 hands 128
Peasant Girl 104–111
 accessories 132
 hands 128
pointing poses 54, 60, 72, 73, 82, 85, 104,
 106–107, 118
positioning 140
Prince, Warrior 66–71
 accessories 132
 hands 128
Princess 54–59
 accessories 132
 hands 128

Q
Queen, Elven 40–45
 accessories 133
 hands 129

R
running poses 23, 35, 85, 91, 99

S
sad expressions 37, 57
scale 50, 143
shadows:
 to create 138
 to deepen 151
shield wall stance 29

shocked expressions 75, 87, 125
silhouette 137
sitting poses 27, 33, 53, 55, 58, 70, 77, 89,
 95, 97, 109
sky, to blend 151
sleeping pose 53
slender build 16–17
smug expression 126
soft focus 138
Sorcerer, Evil 78–83
 accessories 134
 hands 130
Sorceress, Wicked 60–65
 accessories 135
 hands 131
spell-casting poses 53, 61, 73, 74–75
stay away pose 104–107
stocky build 14–15
surprised expression 25, 37, 49, 75, 87
swordplay pose 30–31

T
texture, to create 151
thinking expression 43, 57, 63, 69, 75, 81,
 101, 107, 121
thinking poses 27, 52, 58, 76, 90, 94, 99,
 108
threatening expression 127

U
underdrawing 150
undergarments:
 Cleric 92
 Elven Queen 42
 Evil Sorcerer 80
 Goblin 120
 Norseman 114
 Peasant Girl 106
 Warrior Prince 68
uplighting 136

V
victory poses 23, 26, 78, 88

W
Warrior Dwarf 84–89
 accessories 133
 hands 129
Warrior Prince 66–71
 accessories 132
 hands 128

Warrior Woman 28–33
 accessories 135
 hands 131
 to paint 152–153
weapon handling:
 Barbarian Warrior 24–25, 26
 Cleric 92–93, 95, 97
 Elven Warrior 36–37, 38
 Goblin 120–121, 122, 123
 Norseman 114–115, 116, 117
 Peasant Boy 100–101, 102
 Warrior Dwarf 86–87, 88
 Warrior Prince 68–69
 Warrior Woman 30–31, 32
 Wicked Sorceress 64
 Wizard 74–75
Wizard 72–77
 accessories 134
 hands 130
worried expression 127

Y
yours to command pose 62–63

Credits

Author's Acknowledgments

I would like to thank the following people for their contribution to the production of this book through their patience, generosity, support, and enthusiasm:
Peter Read, Lee Saphir, Trisha Telep, Ronald Van Dauren, Raymond Griffiths, Michael Hyde, Dan Poole, Deborah Newbold, Paul Adams, Lucy Shaw, Rob Walters, O'Neil Johnson, Alicia Ryan, Miah Vu, Dawn Sutherland, Vicky Trower, and Graeme Mackenzie.
Thanks also to Ricky Thaxter, Richard Dudley, Donald Fearney, Cormac O'Neil, and Martin Norris. And especially Liz Pasfield, Anna Knight, and Julie Joubinaux of Quarto Books for their faith in me that I could deliver the goods!

Quarto would like to thank all of the models who contributed to the book. Thanks also to Glenn Fabry, Anne Stokes, and Patrick McEvoy.

All photographs and illustrations are the copyright of Quarto Publishing Inc.

While every effort has been made to credit contributors, Quarto would like to apologize should there have been any omissions or errors—and would be pleased to make the appropriate correction for future editions of the book.